THE WENGER REVOLUTION

THE WENGER REVOLUTION

THE CLUB OF MY LIFE

FOREWORD AND COMMENTARY BY ARSÈNE WENGER

WORDS BY AMY LAWRENCE PHOTOGRAPHY BY STUART MACFARLANE

BLOOMSBURY SPORT

LONDON · OXFORD · NEW YORK · NEW DELHI · SYDNEY

BLOOMSBURY SPORT
Bloomsbury Publishing Plc
50 Bedford Square, London, WC1B 3DP, UK

BLOOMSBURY, BLOOMSBURY SPORT and the Diana logo are trademarks of
Bloomsbury Publishing Plc

First published in Great Britain 2016
This updated edition published 2018

A catalogue record for this book is available from the British Library

*At least 8% of the publisher's net proceeds from the sale of this book will be
donated to The Arsenal Foundation (Charity No. 1145668)*

ISBN: HB: 978-1-4729-6420-5;
ePDF: 978-1-4729-6422-9;
eBook: 978-1-4729-6419-9

2 4 6 8 10 9 7 5 3 1

Designed by Katie Baxendale in Meta
Printed and bound in Glasgow by Bell and Bain

Bloomsbury Publishing Plc makes every effort to ensure that the papers used
in the manufacture of our books are natural, recyclable products made from
wood grown in well-managed forests. Our manufacturing processes conform to
the environmental regulations of the country of origin.

To find out more about our authors and books visit www.bloomsbury.com and
sign up for our newsletters

CONTENTS

FOREWORD BY ARSÈNE WENGER

In England I believe your football club is a part of your passport. You live with it, you die with it. It is a bit like a nationality – nobody in England thinks to change their passport during their lifetime. It is the same for their club.

That gives a club a responsibility. It is not like we have clients who are moving in and out, being with you or with someone else. You have people who you know will go home and cry when you lose a game, who will suffer when you don't play well. So you feel you have a kind of responsibility to make them proud of their club. To make them proud manifests itself in two ways. Of course in a short punctual way that happens through results and the way you play football. But over a longer period I believe the values of the club that carry through the generations make people proud as well.

The popularity of Arsenal became more noticeable when I travelled the world compared to when I was in England. That for me is down to the fact that Arsenal are recognized as a club who has a multicultural acceptance and a club who gives a chance to people who have a dream. It's a series of values we are proud to carry through the years. The club can influence people's lives in a positive way.

The work of the Arsenal Foundation means a lot to me because it reminds me of the way I was educated, and what a club can provide for people. Football clubs in the villages where I grew up in France helped people out. I witnessed it from when I played as a kid. Some people who had no parents find the football club can replace a little bit of the influence of the parents, the sense of family. Those guys were on the fringe of going one way or the other in life, and either the people inside the club, or the game itself because it is a motivation, can be very powerful.

I continue to notice the power football can have to change lives. Football can reach people who seem to be beyond help and bring some normality to their life again, giving them a purpose through that chance to be part of a team. That structure and motivation gets them back on the right path. Football has an educational and a social responsibility and that is at the core of what Arsenal is about.

During 22 years at one club it became natural to feel responsible for every bad thing that happens to Arsenal and proud of every good thing that happens. I always say when you wake up in the morning and you can go to a football game, you think it can be a moment of happiness in your life. We have to try to give that to people.

Arsenal has become my passport. Only six months in a club nowadays is massive, so 22 years makes you feel forever attached. Of course it has become my identity. My passport is red and white in fact.

Through the victories or defeats, what will remain is the formidable human aspect of the last 22 years – that is special and I will cherish that. I had fantastic human experiences at the club. Above the results it was a human adventure.

Arsène Wenger

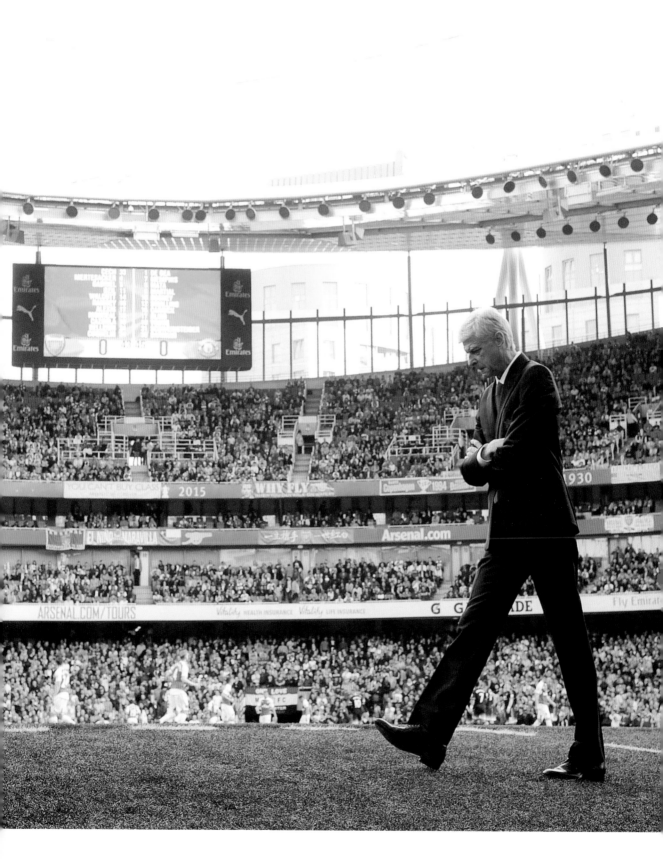

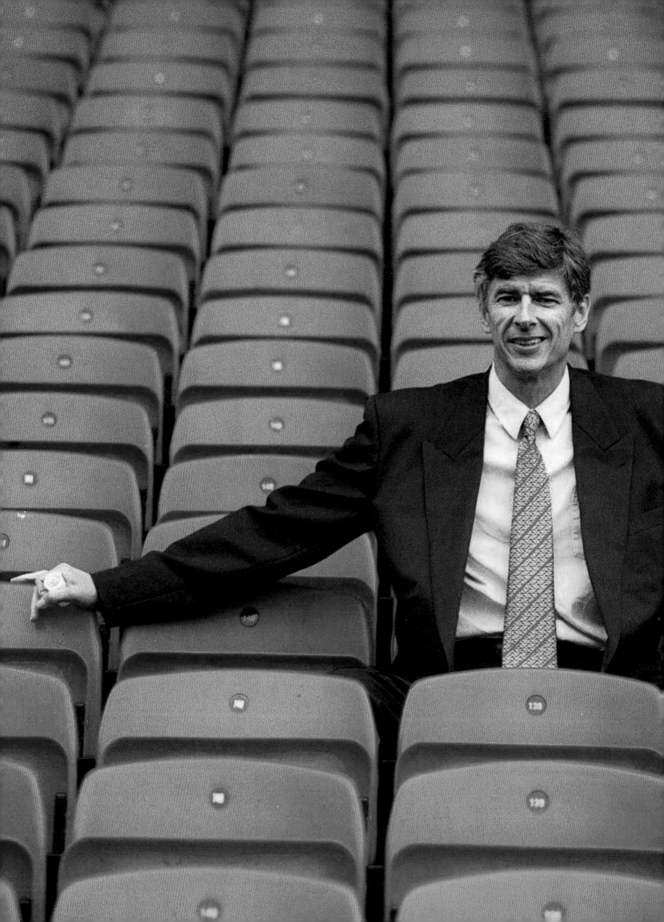

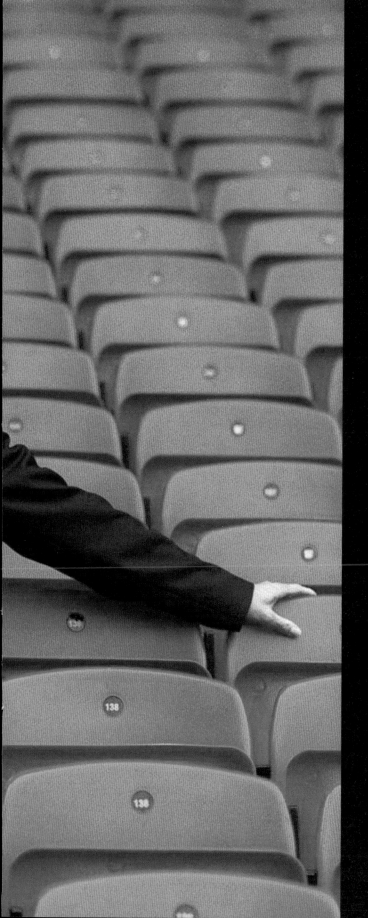

1

ARSÈNE WHO?

‘That's a very young man that I don't know any more! At the time I didn't feel as young as this man looks here. He was full of hope, full of belief as well. Without belief it is not very easy to do my job. He looks to be a happy man as well, to come here and sign for a big club and have an opportunity to do well in England. It was a huge adventure. I didn't really know what to expect.’
Arsène

Twenty years into the job, Arsène Wenger looks momentarily lost in thought, almost taken aback, when he takes a moment to look at his former self. He studies a photograph taken on his very first day as manager of Arsenal, two decades previously. It seems to move him like a form of time travel. The Arsène Wenger of 1996 is wearing a dark suit and the slightly garish club tie of the times, sitting in the Clock End, arms casually outstretched over the backs of the row of seats. His expression reveals a man absolutely in his element. He is relaxed, ready, and motivated to show what he knows he can do.

It's striking to recall how few people in England shared the confidence he had in himself. The vast majority of the football public, the Arsenal supporters – even some of the players – felt some reticence. Who is this guy? What will he be like? Is it even possible for a foreign manager to cut it in England? History didn't offer any evidence of that. The Wenger of today looks back at the Wenger of day one and remembers it well. 'I felt quite a lot of scepticism', he admits.

But in himself, he felt very assured. Although he was new to almost everyone in the English game, he did not see himself as a novice. He was 46 years old and had already been learning, and putting into practice, his football ideas professionally for almost 20 years. 'I already felt quite old at that stage', he explains. 'Let's not forget I already had 12 years at the top level when I came to Arsenal, with responsibility for spotting, buying and training players. Long before that I started to scout at the age of 27, 28. So I already had a long career behind me.'

That had been mostly in his native France, but also his methods had been shaped by a left-field career choice to go to Japan. Returning to Europe to join Arsenal was a move that felt loaded with significance to him, as he had wondered whether he might stay in Asia for the long term. 'Coming back to Europe was a big decision for me', he says. 'It was a new start in my life'. A big part of his personality is to approach challenges with intellectual rigor, a workaholic's determination, and a human touch. His time in Japan had showed him the value of using his own strong ideas with an open mind. 'I always had a kind of confidence in myself and a nature for questioning myself.'

That questioning spirit led him to conclude that the best way to make this Arsenal experiment work was to meet in the middle of his way and their way. 'I could understand my acceptance would depend upon that mix', he says. 'I didn't want to compromise what I thought was important in order to push through the elements needed for the success of the team. But also I wanted to adapt to the local culture. I did not forget that this country has created this sport.'

That melange manifested itself in the way the team evolved. It became an innovative mixture of old fashioned English commitment – the physical determination and never-say-die attitude embodied in the famous back four of Lee Dixon, Tony Adams, Steve Bould and Nigel Winterburn – and the technical refinement that arrived with Patrick Vieira, Emmanuel Petit, Marc Overmars and Nicolas Anelka. The qualities of each group rubbed off naturally on the other. Of course Dennis Bergkamp, who defined the best of all worlds, was already at Highbury, so Wenger had a brilliant example at his fingertips.

What was surprising was how quickly the team style came together. Wenger's ability to identify and recruit outstanding talent was paramount. A new dimension was added to the way Arsenal played football. The team knew how to defend for its life, but also lacerate opponents with spellbinding speed and swagger. It made for a thrilling contrast to the 'Boring Arsenal' stereotype that had lingered for years.

Arsenal ended the 1997–98 season, Wenger's first full campaign in England, as double winners. Manchester United were the dominant force in the Premier League, but over the course of the season were overtaken by Wenger's fresh approach. Then, in the FA Cup final under a burning sun, Newcastle could not live with the zest of Overmars and Anelka. That general air of scepticism that the manager had felt when he started work in London N5 was obliterated.

Some 19 months after he walked into Arsenal Football Club, nobody would be daft enough to ask 'Arsène who?' any more. English football was in the middle of a period of seismic change. It was flush with new money, broadening its horizons, and welcoming global influences. The sight of a once unknown Frenchman hoisting the biggest prizes was symbolic of this blazing new world.

The French connection was fundamental in helping the new boss to implement the style he wanted to achieve.

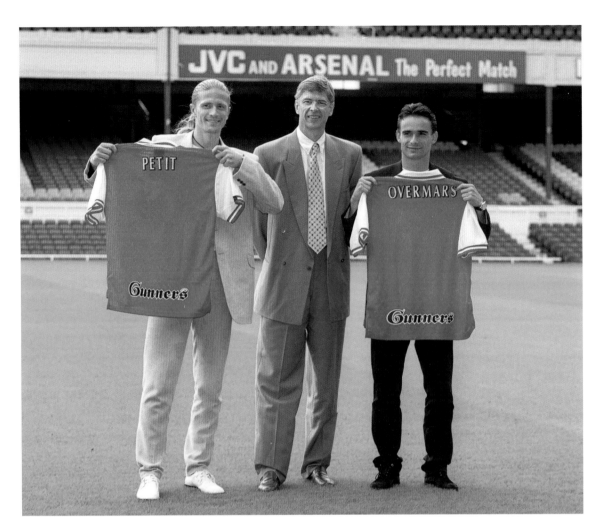

‘Emmanuel Petit and Marc Overmars were very important buys. Adapting to the English style was interesting. Even players like Petit who was a tough boy were saying, "What's going on here? We get fouled and fouled and fouled and the referee lets it go?" What people forget is that 20 years ago you had to be tougher than today when you came from abroad.’
Arsène

An early training session. The most striking thing was the stretching. The players were quite baffled by it.

Arsène Wenger's first home game was a 0-0 draw against Coventry at Highbury. Who could have imagined what lay in store?

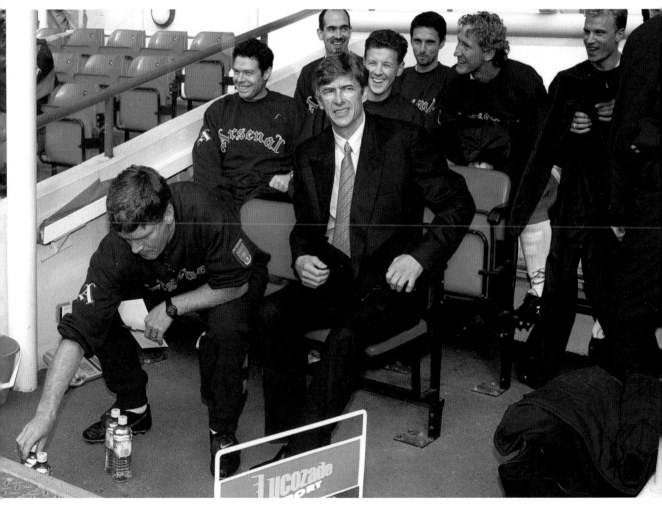

This was the goal, finished coolly by Marc Overmars, that tilted Arsène Wenger's first title. The challenge to topple Manchester United was on.

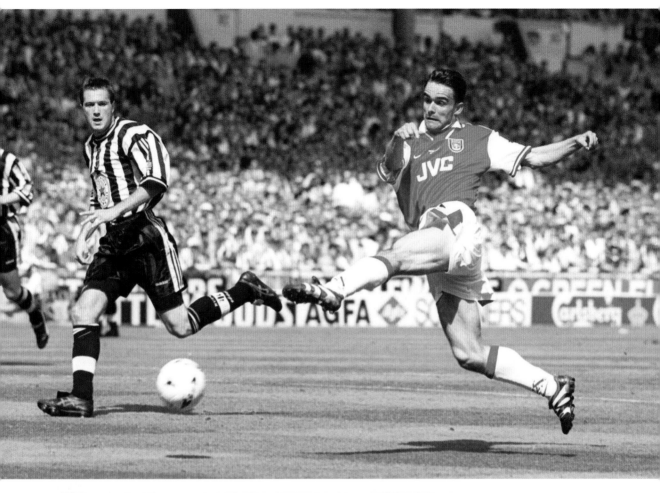

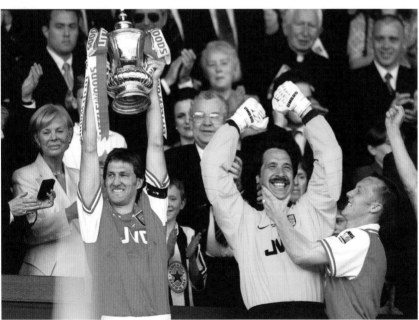

It was a big moment to beat Newcastle in the FA Cup final at Wembley, confirming the double, a historic feat that the club hadn't achieved since 1971.

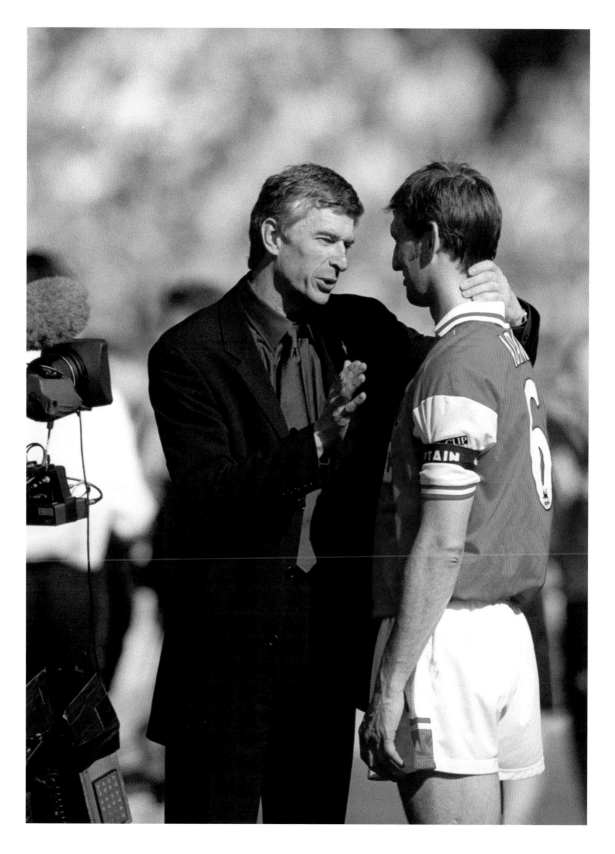

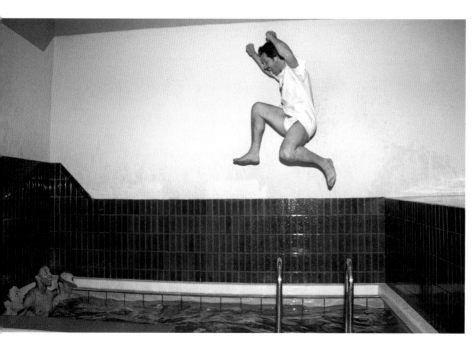

‛I never saw these things. I am always with the press at this point when the players feel the moment as they get back in the dressing room. I was unaware of these things. I did not see them at the time. Everybody jumping in the bath is not something you would see everywhere in the world. It is an English thing.'
Arsène

In the dressing room there were no inhibitions. Stuart MacFarlane had been covering Arsenal since 1990 and became their official photographer in 2001. He recalls the impact it had being in the inner sanctum at important moments: 'It made me really feel part of the club to be a part of that. I got absolutely soaked. I got thrown in the bath as well and when I left the dressing room I had to walk past all the press to exit the stadium leaving a trail of water as I squelched out of Wembley.'

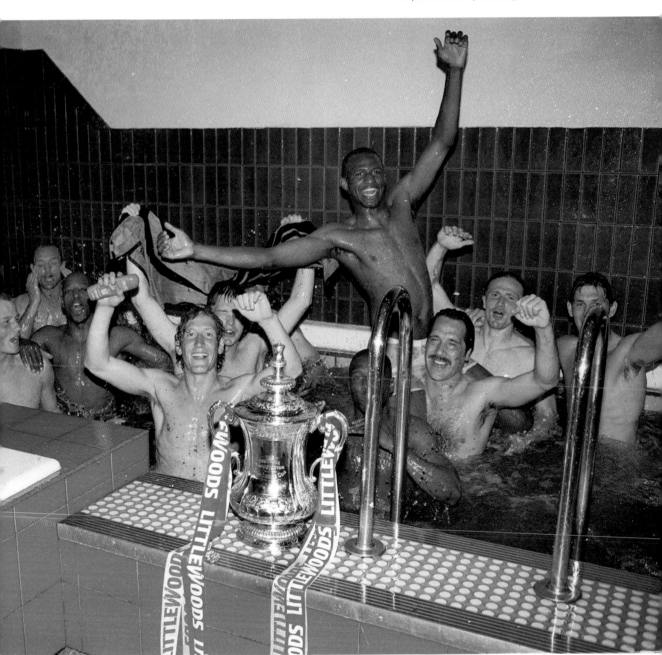

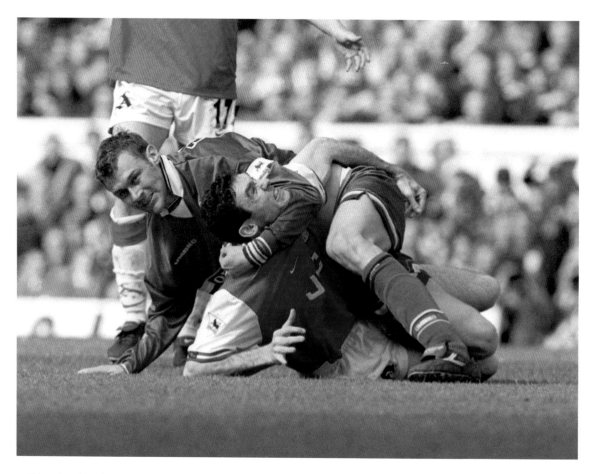

'This epitomizes the English style of the time.
There were some good photographers who
could catch people in unusual positions!
Martin Keown could handle anyone – even
Duncan Ferguson. This was the day we won
the league, beating Everton 4-0.'
Arsène

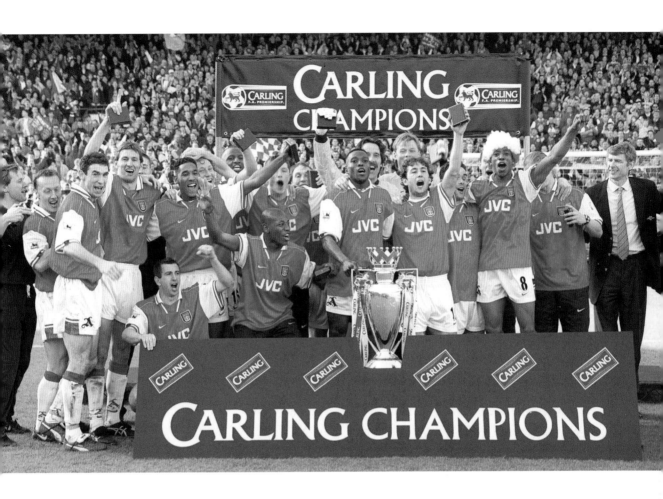

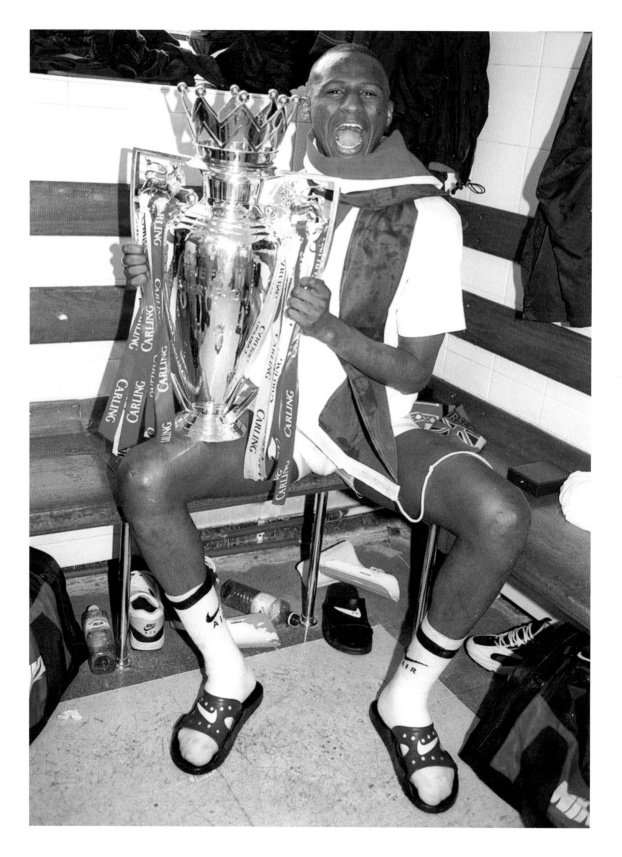

'Here is the man who maybe gave me the first credibility. Because he is here with a trophy, he looks very happy, he was an exceptional football player. When you think at the time you buy an exceptional football player for 5 million dollars ... That does not exist any more. I remember having bought Patrick while I was in Japan. He was signing at Amsterdam for Ajax, and I intercepted him. The first time he played, he came on in the first half, it was a shock to people. He was like a genie from the lamp.'
Arsène

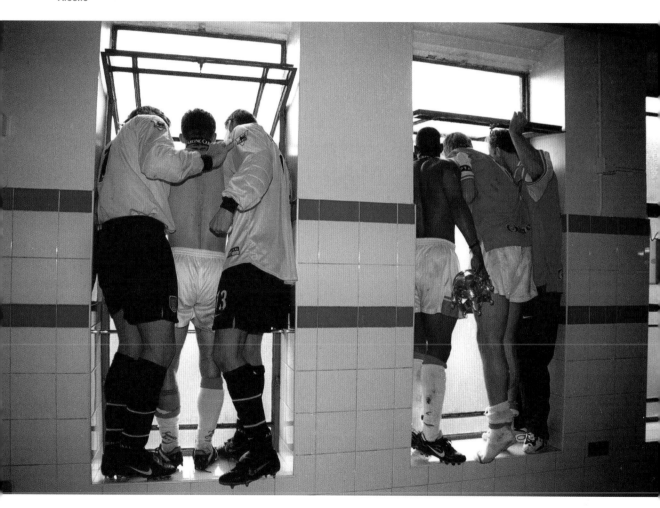

That image says a lot about Highbury and the direct connection between the players and the fans. This collection includes David Seaman, Marc Overmars, Alex Manninger, Ian Wright, Tony Adams and Dennis Bergkamp. They wanted to show the fans outside in Avenell Road the Premier League trophy, and it was quite a climb to get up there, up above the baths. On big occasions the players couldn't resist getting up there to see the fans.

2

ALL CHANGE ON THE TRAINING FRONT

'Talking to the players is what I love to do. I talk to the guys that couldn't wait until the end of school to go and play football. Professional football kills that. Professional football is always "you have to". Creative football is "I want to". For us as coaches it is important as well that we speak to the fun, the desire, the creative side of human beings. I meet 50 people who love Arsenal during the week. They tell me: "You have to win." I've been in the job long enough to know that. It is not something I ignore. But my job is to think how can we win? Just to say to the players "you have to win" is not enough. You have to create an atmosphere and a desire to play together, to create connections between the players, to give you a chance to win. Unfortunately it doesn't always work.'
Arsène

t is not a particularly useful exercise for any manager to analyse the percentage of their time that is spent doing what they love in football compared to the hours fulfilling all the obligations that are considerably less appealing. Do managers adore the regular grind of the press conference? Do they dream of batting off phone calls from agents? Do they feel the joy of hours on a team bus trundling along some motorway in the early hours after a midweek game? Wenger is too polite to wince, but modern management is a kind of trade-off for him. Tolerating the things he doesn't enjoy permits him the pleasure of being out on the training ground with his players. Those moments are the precious ones.

He loves to talk to his players. He loves to watch them try out the details he wants them to absorb. 'If you take that off me I lose my appetite for managing', he says. 'You have to find a balance between your masochistic endurance and your passion. Because you do a lot that you don't like. I suffer a lot doing things that I don't like to do because I know that allows me to do what I love to do.' The training ground has always been his sacred place. He is not a manager who likes to delegate at training. He wants to observe the fractions of improvement, the body language, the nuances and mood within the camp every single day.

Analysing the working life of the club he joined in 1996, Wenger was incredulous to discover the conditions were initially nowhere near the standards he would have expected. Arsenal were apparently forward thinking, yet in terms of training facilities they were stuck in the past. Renting a training ground from University College London, a set-up designed for students not elite athletes, was simply not good enough. Moderate facilities were not ideal, having to sometimes leave the pitches so the students could play was even worse.

With extraordinary timing, there was a fire at the old training ground, which advanced Arsenal's efforts to create a base which became in every way more suitable. The club bought the land next door to the fields they had been hiring for decades and began to build. Wenger oversaw the project and ensured it was up to the highest standards available. 'It was that first big change in our structure at the club', he says. 'With Gary Lewin [the physio at the time] I came here every day while it was being built, to change this and that. We managed from the first day onwards to make it functional, clean and a place that really works.'

The redeveloped training centre at London Colney became Arsenal's sanctuary. The attention to detail and the little touches Wenger insisted upon are evident across the building. There is an abundance of natural light, outdoor shoes have to come off before anyone enters the inner sanctum, everything from the chairs to the cutlery in the dining room were chosen to be particularly comfortable to use, there is a waterfall in the eyeline of those using the gym to promote a sense of relaxation.

A feeling of serenity around the place is paramount. 'Why? Because football has become extremely popular', says Wenger. 'It inspires a lot of interest from the media and the public. The stress for players now is much higher than before. On top of that the freedom in society has gone for players. They don't feel protected anywhere anymore. To have that sanctuary at the training ground is important.'

It is a sign of how the game has developed even in the life of the new training ground that Arsenal upgrade their training centre regularly. Construction work has been going on recently to reflect the most up-to-date requirements. Echoing that, at the club's youth Academy at Hale End millions have been spent to modernize the space where the Arsenal juniors are based.

Alongside those developments, the number of staff has grown to give the players the best possible facilities and back-up. Wenger's interest in physiology seemed radical when he first arrived, with a focus on stretching, strength and conditioning experts, nutrition and data analysis. Keeping up with the science is a constant challenge. 'The physical qualities always improve', he says. 'Football is a bit like that. It moves forward. The defence gets better and the response from the attack is to find a problem to challenge the better defence. Then the defence finds a new way to deal with that. It goes on, moving always forwards.'

Life at London Colney is about finding a balance between serious work and enjoyable work. Wenger's philosophy has always been to instil the best of both.

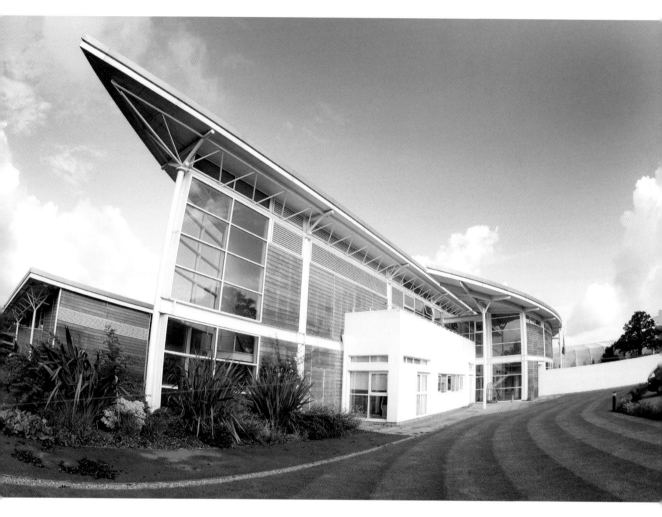

'Oh! This little baby, which becomes bigger and bigger. Now, many years later, I think there are more glamorous training grounds, more luxurious training grounds – because in the meantime everyone has built new centres – but this still has the important ingredients we felt were fundamental from the start: It's very functional, we have a lot of daylight everywhere, it is very clean, the pitches are very good, and the food is very good. Those were five ingredients that were vital and we managed to respect all of them and still do. It changed life here.'
Arsène

‘I am quite proud of the training
ground because what is important to
note is that there were no trees here.
We planted 280,500 trees.’
Arsène

ALL CHANGE ON THE TRAINING FRONT / 29

'The science, how to look after the physical shape of the players, moves forward a lot. Today I am the head of a team of 20 people around me. Before, it was two or three. A manager today has to manage a team outside the team. You spend much more time with your own staff and get inundated with a lot of information, so you have to select four or five pieces of information that are vital at the time and make decisions.'
Arsène

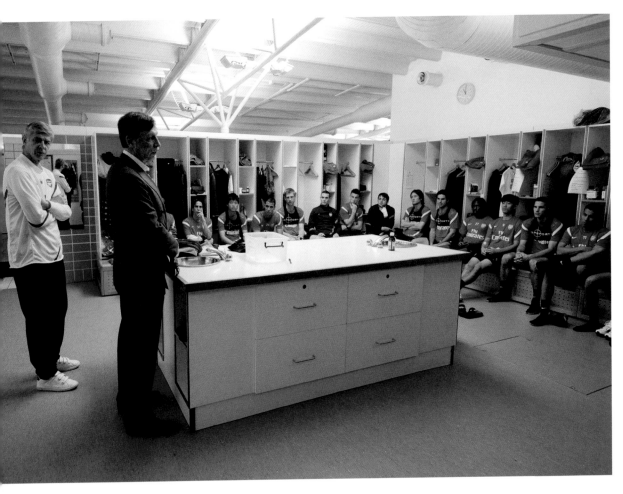

This was the first time Stan Kroenke met the players. The players sat there and were clearly interested in what he had to say. That is not always the case when they get together to be told things.

This is Per and Mesut's first day back after winning the World Cup with Germany in 2014. Arsène welcomed them in the reception area.

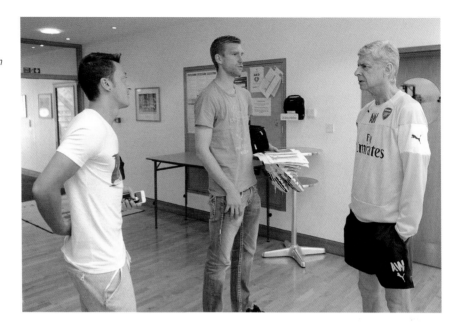

During the traditional Christmas lunch the youth team have to stand up and sing carols to the first team. Arsène seems to enjoy that.

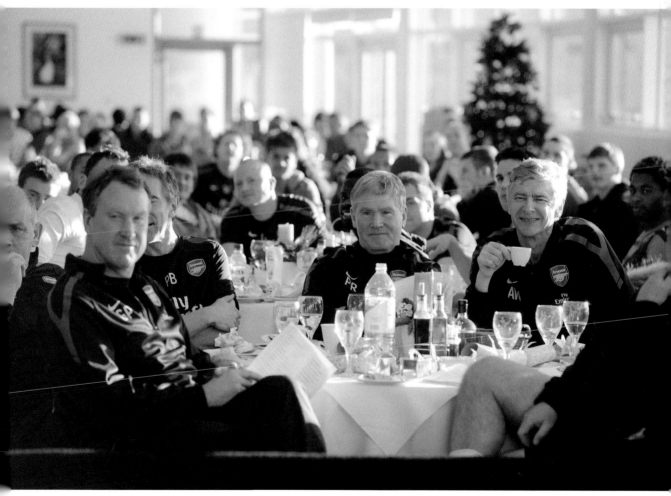

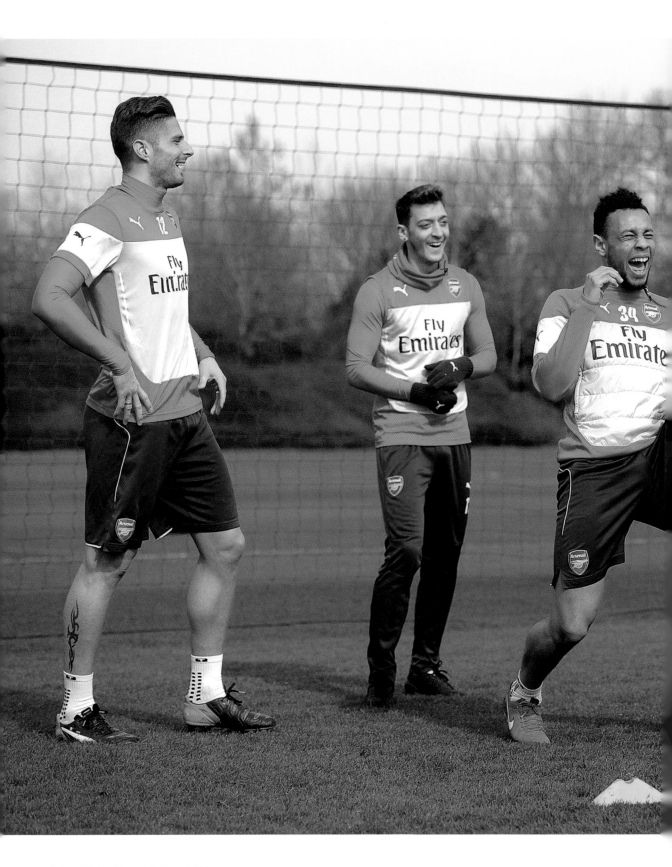

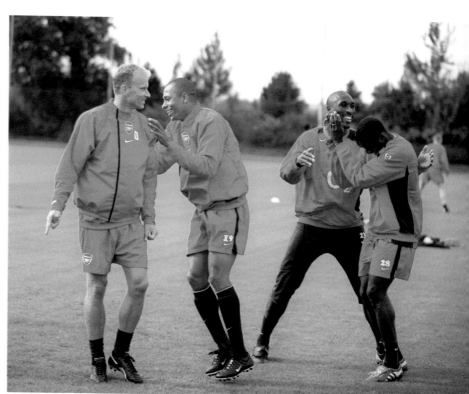

'At the training ground it is a combination of concentration and fun. You want it to be serious but you also want it to be happy. There need to be moments where they only have fun, and moments where they only focus on the job they do. That is needed. You have to be happy to be together. You also have to know, "ok now it is time for me to focus."'
Arsène

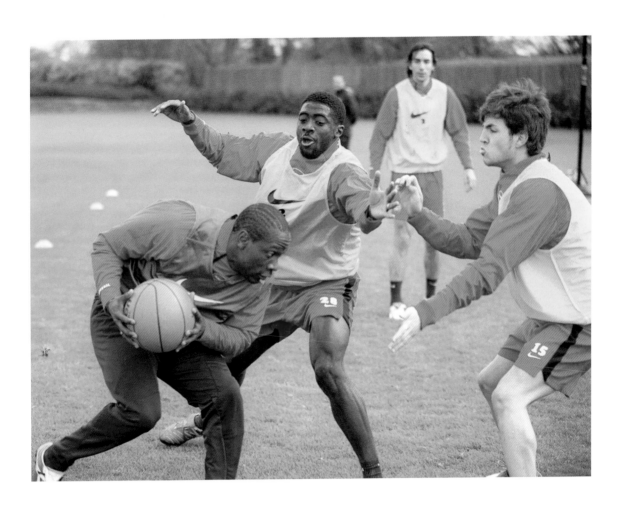

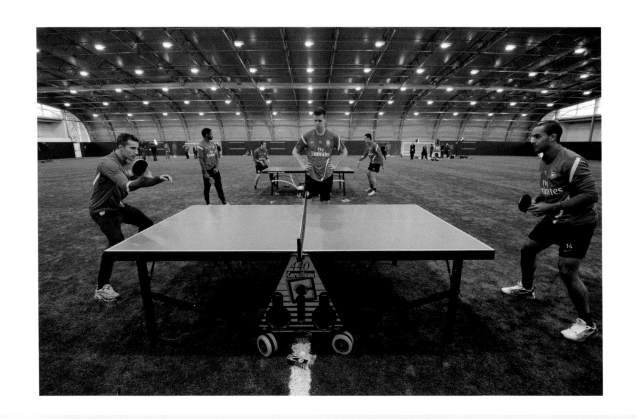

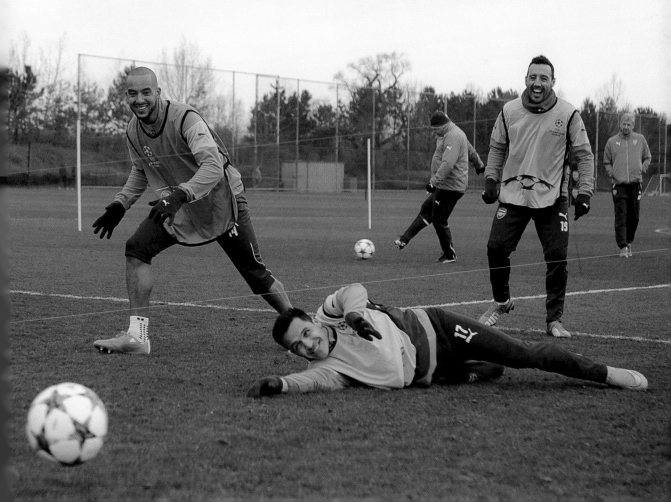

Wow. What a five-a-side team, but who would go in goal?

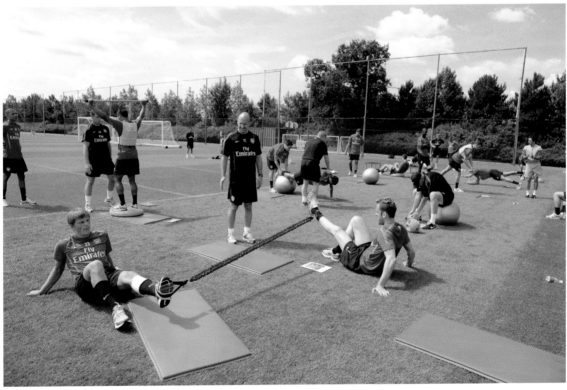

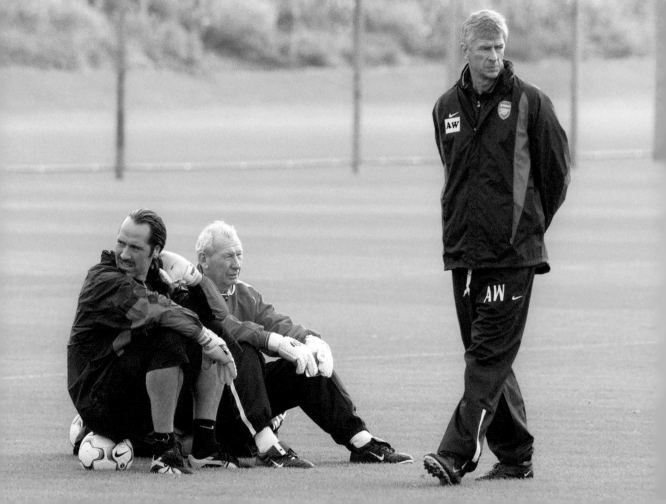

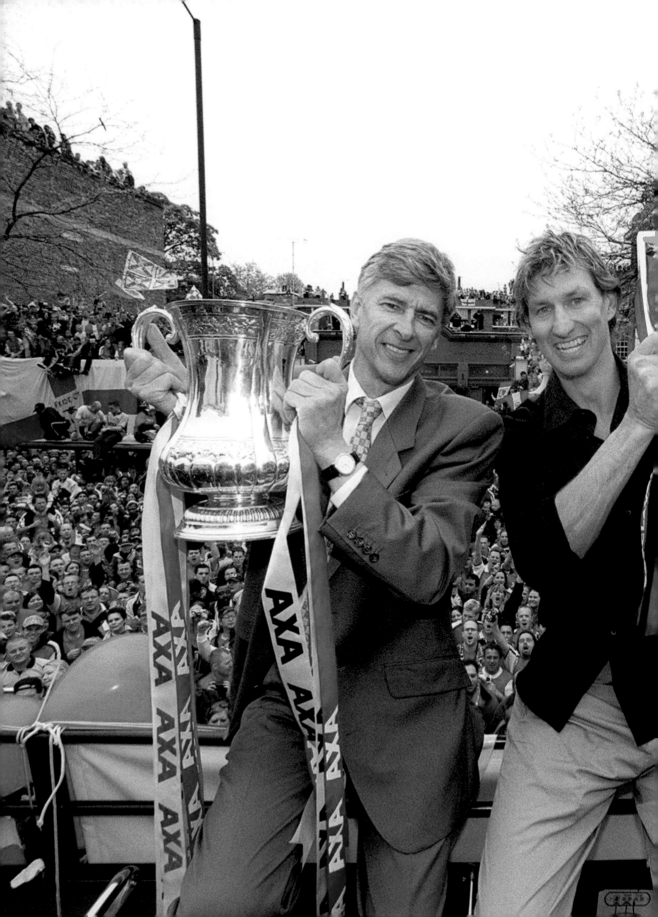

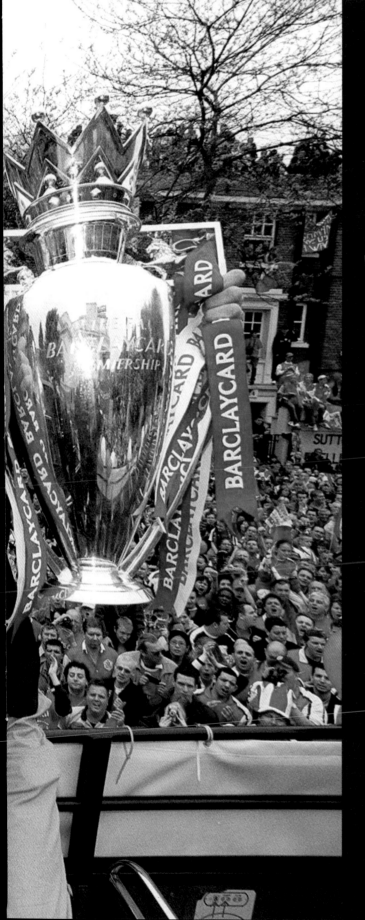

3

STRIVING FOR MORE SUCCESS

❝I am happy to see happy people. That is for me the most important thing. These moments are rare in life, so you cherish them. That is what you fight for, that is what you would like to feel in every single game, but it is the exceptional moments where it comes most strongly.❞
Arsène

Building success is one thing. Maintaining it is quite another. The nature of that first double – surprising, audacious, innovative – meant that there was an expectancy that Arsenal would be a new force. They were to an extent, but the business of winning more trophies to emphasize their raised ambitions proved troublesome for a while.

A frustrating period defined by a series of near misses was challenging for Wenger. Domestically, Manchester United lashed back out like a proud, wounded animal. Arsenal finished runners-up in the Premier League for three seasons in a row between 1999 and 2001. At the same time, they managed to reach two cup finals which they contrived to lose painfully. The 2000 UEFA Cup Final against Galatasaray was a story of dominance without any reward followed by a dreadful penalty shoot out. Mention the 2001 FA Cup final against Liverpool to Thierry Henry today and the hurt of a ridiculous missed opportunity still stirs. He can recall with crystal clarity how a certain goal was stopped by a handball but the referee missed it. No goal for Arsenal, no red card for Liverpool, and in the end, no trophy. In total, Arsenal came second in a competition five times over three seasons. That kind of pattern can get into a team's subconscious.

During that period, Arsenal had another problem to contend with. One of the consequences of the attractive team Wenger created was that the players became coveted elsewhere. A number of the key components to the team who won the 1998 double were tempted by Europe's super clubs. Anelka left for Real Madrid in 1999. Overmars and Petit moved together to Barcelona in 2000.

Wenger needed to be resourceful. Some inspired forays into the transfer market introduced new impetus. How do you replace the high-velocity scoring presence of Anelka? It turned out Wenger did one of the most extraordinary deals of his managerial career. With the £23 million he received for Anelka, he generated enough funds to pay for the new training ground and buy Thierry Henry from Juventus. Elsewhere in the team, Overmars left, Robert Pires came. Petit left, Edu and Gilberto came. All of these new arrivals fitted the blueprint of a classic Wenger player: High-calibre technique, a winning spirit and the kind of warm solidarity that would fit into the dressing room.

There was one other critical transfer that happened during these early years that made a massive impact – the recruitment of Sol Campbell. As deals go, signing the captain of local rivals Tottenham on a free transfer rang high on the staggering scale. The squad was evolving. While still based on the 1998 double prototype, it became a variation on that theme that felt ready to target trophies with more conviction again.

Getting over that mental block of consecutive runner-up finishes was something Arsenal needed to overcome. Momentum started building in the 2001–02 season once the team got over a sticky spell in fortuitous circumstances. They were drawing a big game at Highbury in November against Manchester United when the visiting keeper Fabien Barthez inexplicably gave the ball to Henry. Arsenal were suddenly gifted victory. The atmosphere lightened. The hunger heightened. The corner was turned.

Arsenal lost only once more during the Premier League that season. They also marched through the rounds of the FA Cup all the way to the final. Wenger recognized in the class of 2002 all the ingredients for success.

Over a five-day period in May of that year, Arsenal won the double again. They were able to exert their dominance over the English game because they had a group of talented players willing to fight where necessary. The goal scorers to defeat Chelsea in the FA Cup final epitomized that – Ray Parlour and Freddie Ljungberg: the kind of players Wenger admires for a never-say-die mentality as well as their ability to make a difference on a football pitch.

A few days later Arsenal travelled to Manchester United's lair knowing that a win there would confirm the Premier League title. Sir Alex Ferguson's team, great rivals of the era, played as if their honour was on the line. Arsenal displayed both fire and finesse to win 1–0, thanks to Sylvain Wiltord's strike.

After those difficult in-between years, the second double confirmed that Wenger's influence could not be filed away as a one-season wonder.

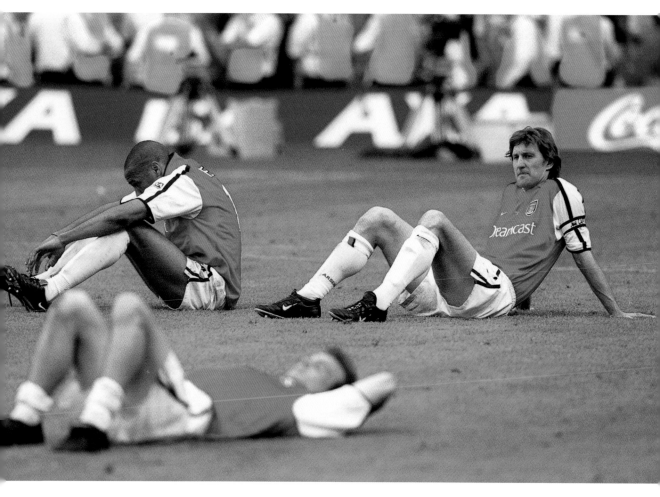

Hard times. Stuart recalls having to photograph painful defeats: 'These were pictures I hated to take but I knew needed to be recorded. This is the first time this photo, taken at the final whistle of the 2001 FA Cup final which was lost to Liverpool in a really unlucky way, has been published as we tend not to dwell on the negatives. I sat next to Ashley Cole on the bus home and told him, "Don't worry we will be back next year". I remember thinking, what did I say that for? You don't get too many back to back cup finals.'

'Should Desailly have closed him down? Exactly. Ray Parlour was not expected to score a goal like that.'
Arsène

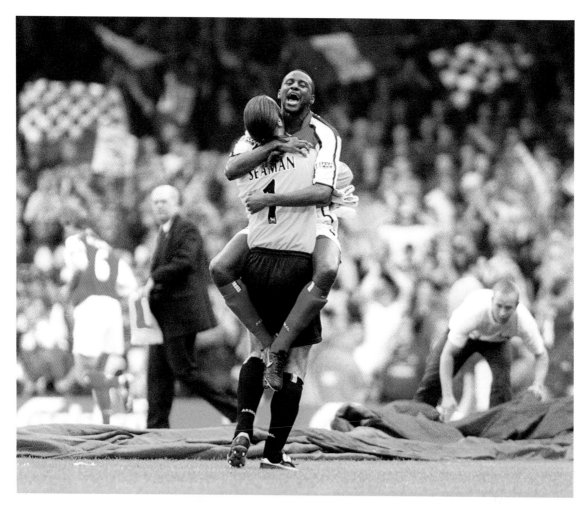

Arsenal were closing in on another double and it was a wonderful day to beat Chelsea to win the FA Cup. Everything that seemed to go wrong the year before went right this time.

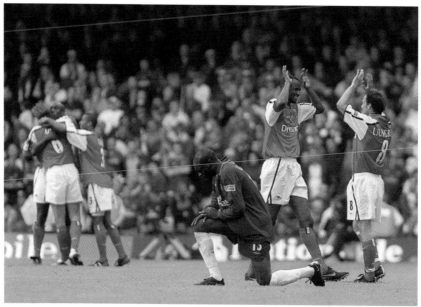

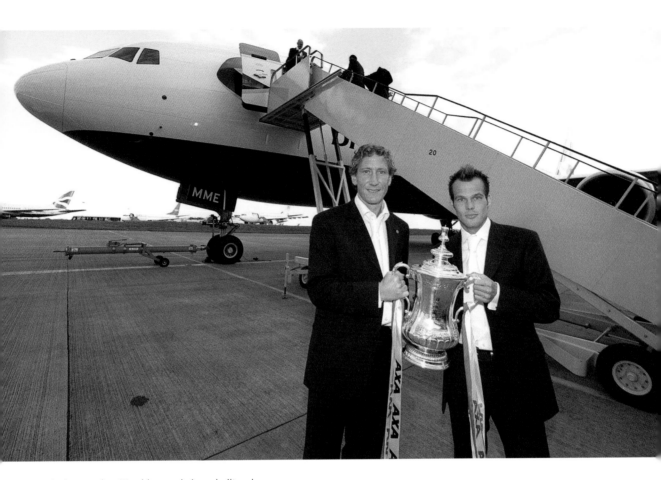

In the era when Wembley was being rebuilt and the FA Cup final took place in Cardiff, Arsenal flew there and back. A photograph with the trophy outside the plane felt like a good idea. Having said that, there was so much turbulence on the flight it's lucky the trophy got back without any damage. A few of the players were gripping on to their seats.

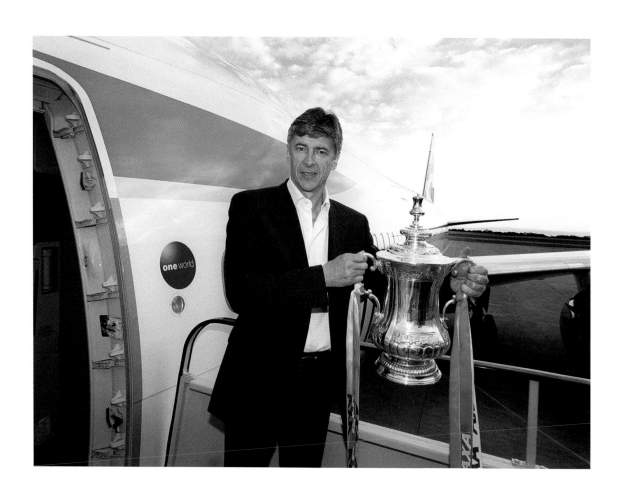

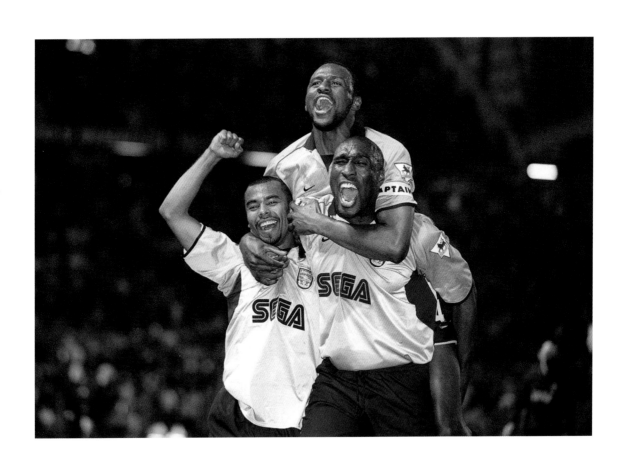

'Winning the league at Old Trafford was a proud moment. We had not a lot of the ball that night, and got a lot of kicks, but we won the game thanks to a great solid attitude and Sylvain Wiltord's goal. Of course these were exceptional moments. We didn't lose an away game, and that planted a seed for me to say ok, let's go further and not lose a game at all.'
Arsène

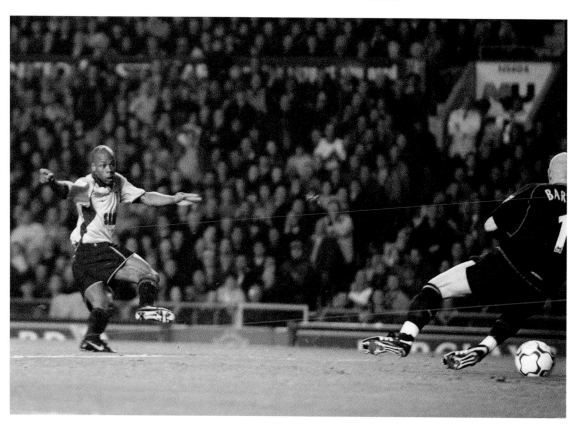

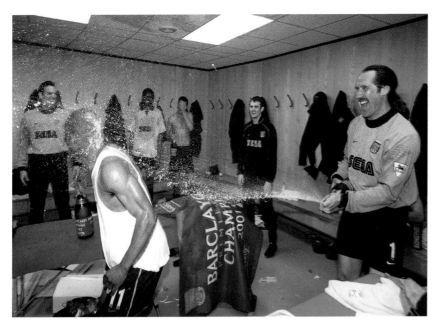

The Arsenal players were in the dressing room and Freddie Ljungberg asked Stuart whether the fans were still in the stadium. The photographer ran out of the tunnel at Old Trafford to check and found the visiting supporters still celebrating in full voice. As Stuart recalls, 'The whole squad bounded out. "Let's go!" I was trying to run to keep up with them so I could capture them celebrating in front of the fans.'

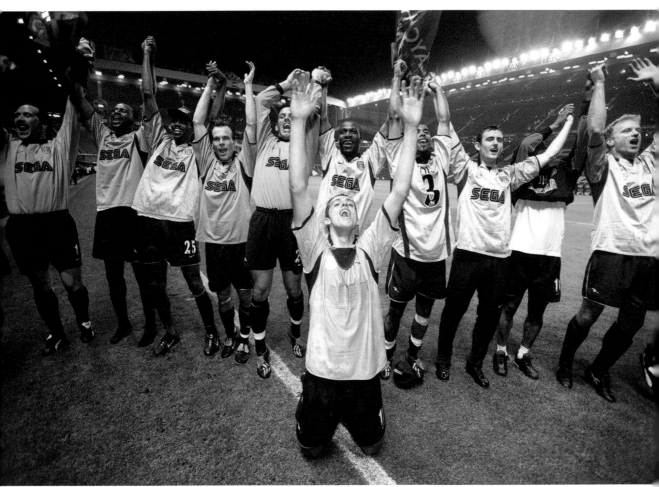

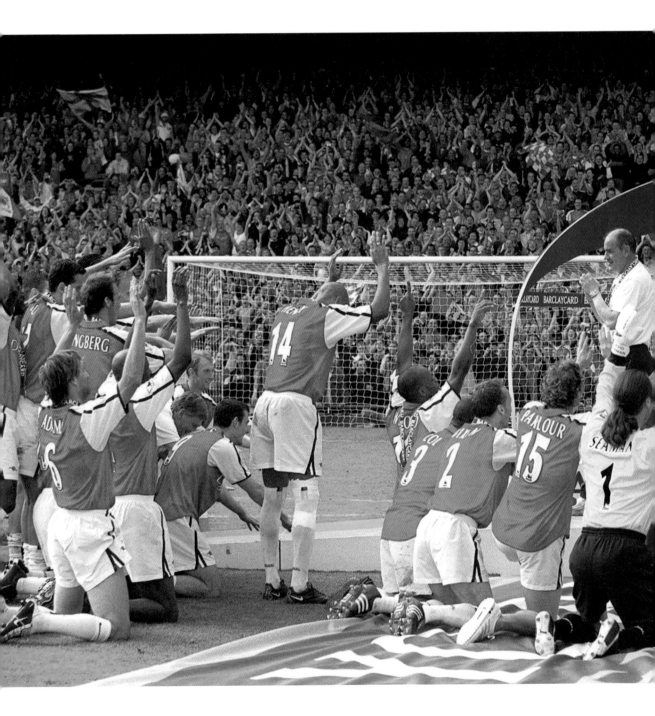

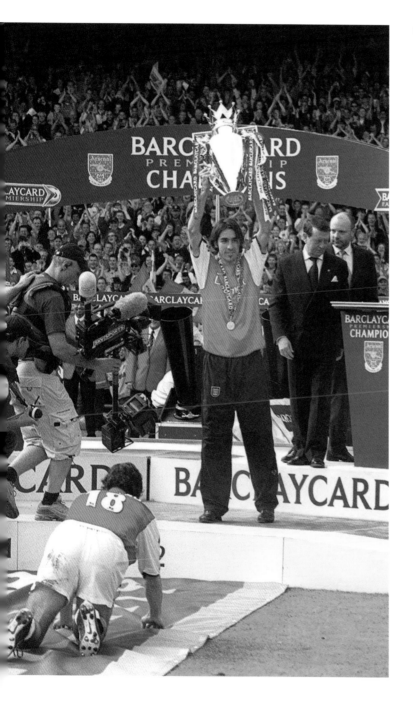

‘This shows what the players thought of Robert. You want to be acknowledged by your peers as a great player. I think he should put that photo in his living room blown up much bigger. It was a moving moment. Robert suffered a big injury and missed the 2002 World Cup because of that. I still feel guilty today because before the game against Newcastle when he got injured I didn't want to play him. Until Friday I thought I will rest Robert on Saturday, and then on Friday morning I changed my mind. He was at that period for me the best left-sided midfielder in the world. During the game I was saying I was stupid for wanting to rest him because he was so good on the day. He alone won the game in the first 20 minutes. And then he did his cruciate. To this day Robert is one of those guys that when you give him a football he is happy.’
Arsène

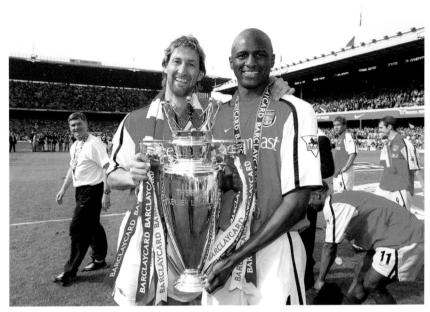

'That is a symbol of three generations of Arsenal captains with Pat Rice in the background behind Tony Adams and Patrick Vieira. These are three huge names in the history of Arsenal Football Club.'
Arsène

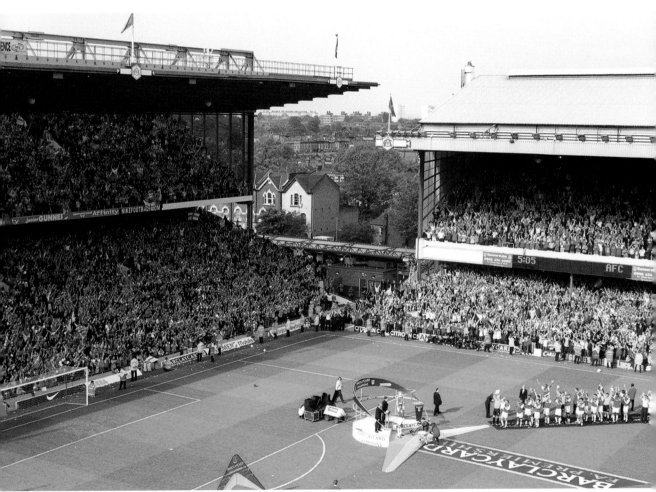

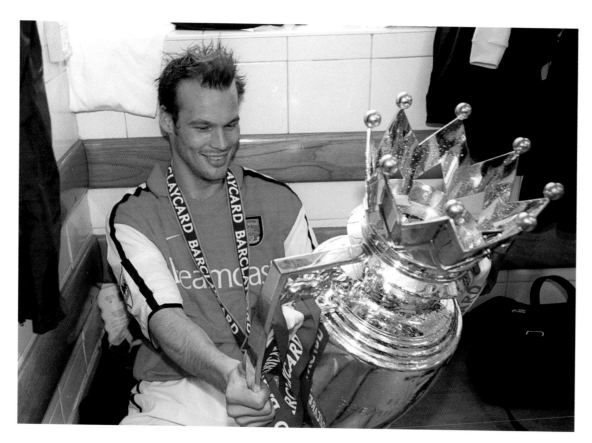

'That is the real moment where you realize how big the club is. Of course it's exceptional. The attendance at your stadium is limited. Apart from what you see there, you go home, and you go to training. So you rarely see the support on that scale. These are the moments where you realize. Basically it is scary and fantastic. It is both. You think, what happens to all these people if we don't win?!'
Arsène

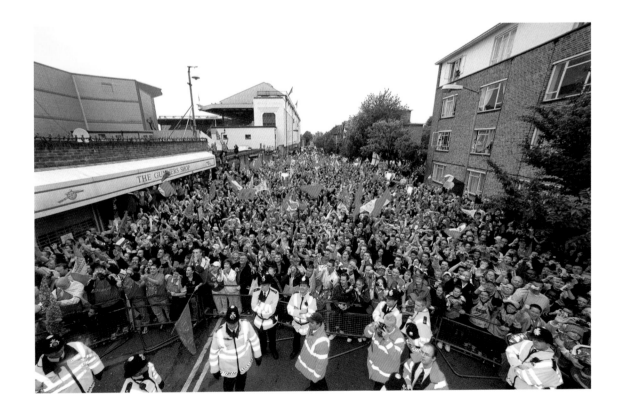

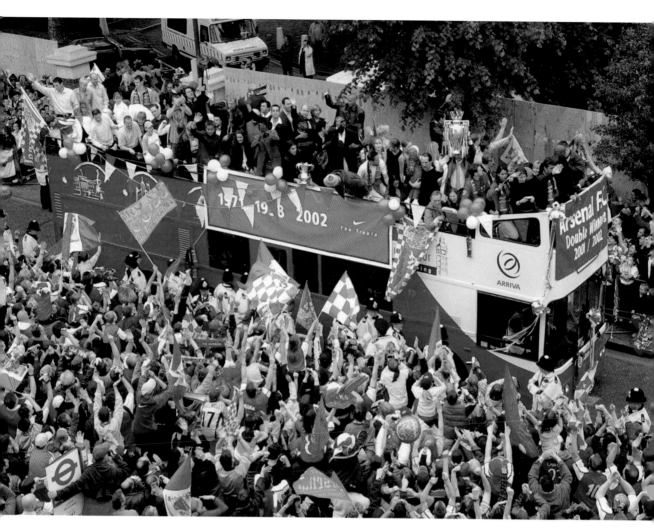

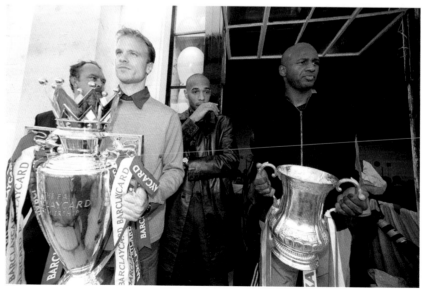

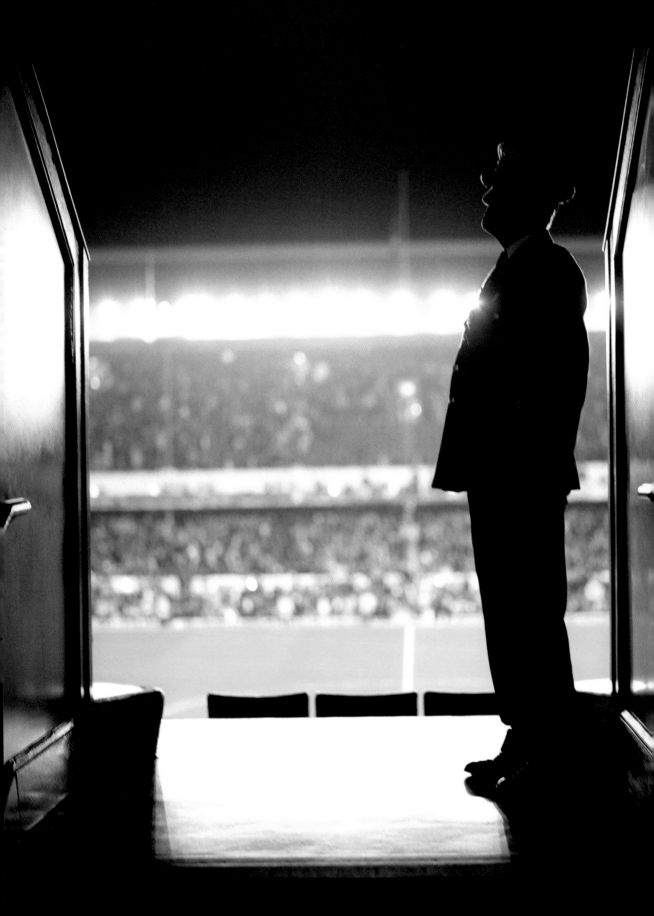

4

HIGHBURY

‘This stadium had a soul
you can never recreate.’
Arsène

Looking intently at some photographs of beautiful old Highbury, Wenger smiles to himself as he weighs up whether to articulate a small confession. 'You will laugh', he says bashfully. 'Sometimes I drive in front of the Arsenal Stadium now, just to see it again, to remember how great it was, how special it was.'

Wenger is generally regarded as more of a pragmatist than a sentimentalist, so that idea that he diverts his journey occasionally to drive along Avenell Road and drink in that nostalgic view is a striking one. It underlines how the soul of a building, the emotions and moments it evokes, means so much more than the materials it is built with. Highbury does that to people. Many fans going to the Emirates nowadays stop by the site of the old ground, now redeveloped into apartments, to pay homage. It is easy to get assailed by memories standing outside the famous art deco façade of the East Stand and the stairs that lead up to the elegant doors into the Marble Halls.

Wenger is nostalgic about Highbury. He remembers his first visit clearly. He was passing through London in January 1989 on the way to scout a match overseas in his role as manager of Monaco. With a day to kill en route, he did what any self-respecting football obsessive would do. He found out if there was a match on – there was, a north London derby no less – and through an acquaintance a ticket was arranged. He got into a taxi and asked the driver to take him to Arsenal.

He recalls the moment the driver came to a stop in the middle of some residential streets in London, N5. 'You would never guess there was a stadium there', Wenger says. 'I said to the taxi driver, "But where is the stadium?" He said, "We are here." Oh, I thought to myself. This is Arsenal.'

Some years later, when it became his footballing home, the place where he sent his teams out to play, where the pressures and dreams collided, he would learn to love all the heritage of Highbury. The identity of the club was entwined with this place. 'There was something there, a history in the walls', he says. 'When you see tapes of the 1950s and recognize the dressing rooms it is something absolutely fantastic. I remember Ian Wright shouting from the showers with the spectators outside the windows. You have so many

experiences in there of course it is so special.' Like any old building it had its own idiosyncratic noises. Another nod to the past was one of the old tales passed down that people sometimes heard the footsteps of the ghost of Herbert Chapman, the first great visionary manager Arsenal had back in the 1930s, walking through the Marble Halls where his bust famously overlooked the entrance. The commissionaires that stood guard and welcomed visitors represented a sense of the old fashioned style that had been a part of the Arsenal way for decades.

The trophy collection from the early part of Wenger's Arsenal is richly associated with Highbury, almost as if it was another strong player in the group. But throughout that time there was a ticking time bomb. Football was changing at such a pace, with interest in the game surging and demand to be a part of it swelling, the question of whether the club was outgrowing its beautiful home was a sensitive and critical one.

Arsenal had moved to Highbury in 1913, and in the course of the stadium's life had seen attendances peak at 73,294. The introduction of all-seater stadia meant that in its final years it could fit in a little over half that figure, 38,500 spectators. There were more names on the waiting list than those lucky enough to have season tickets.

'We were a football club who every week turned down people who wanted to come to the game and we needed to grow', explains Wenger. 'The directors were very brave, and I was very stupid, but we did it. I had doubts when I saw the spiralling costs. At the start we could afford £250 million but we ended at something like £430 million. On top of that it was bad luck the property crisis coincided with rebuilding Highbury. They were difficult moments.'

The board, partly inspired by Wenger's vision to create a bigger infrastructure to allow the club to try to compete with Europe's superpowers, had made their choice to move. They stuck by it throughout those difficult moments. Even when the worries were genuinely alarming they never deviated from backing Wenger's leadership. Saying farewell to their traditional home would be a challenge as well as a wrench. That seismic decision would be felt in everything Arsenal tried to do in the coming years.

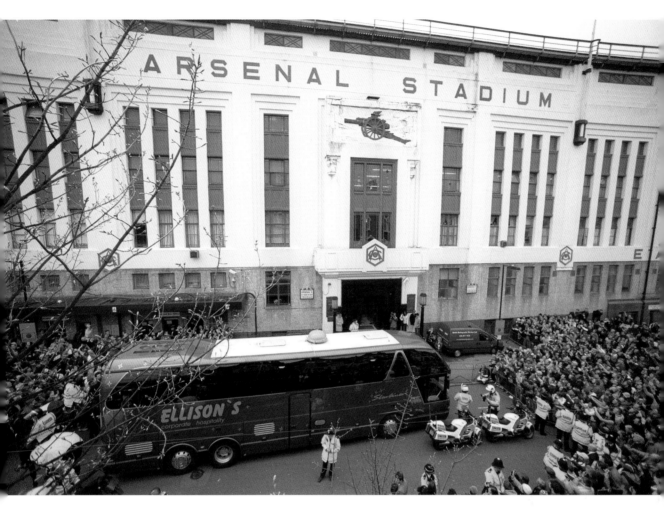

‘I felt always it was a special moment to arrive by coach and turn into Avenell Road, just from the top of the hill, and see the crowd. I never had exactly that feeling again. For me it was always special. Situated there amongst the houses. To find your little way from a car park to the office you had to go through all the corridors. I miss that forever in my life. It is amazing to look back at these pictures because I realize how much it meant. I also liked the tradition of the commissionaire in front of the door.’
Arsène

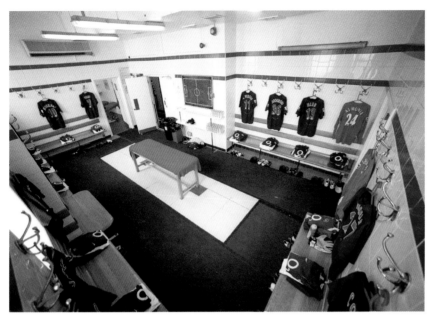

Stuart had half an hour in the dressing room on his own at the last game and until that moment didn't realize how big an impact it would have, how upsetting it would be after it all finished.

Kit man Vic Akers clears up for the last time.

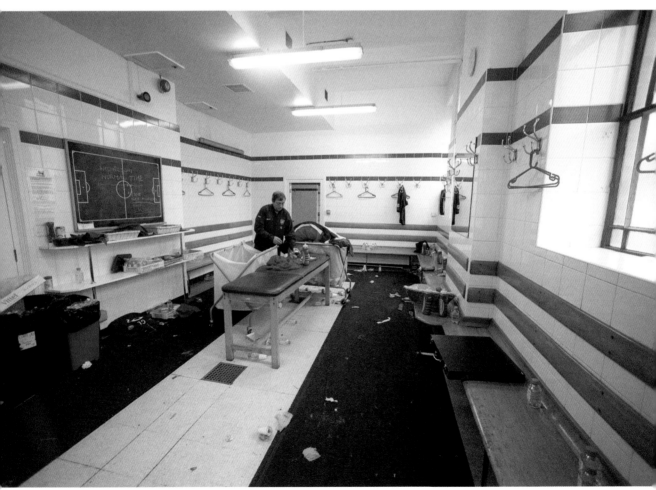

❛I remember the feeling of two teams up close, and the noises of the studs on the stairs. That was something special. I must say as well we had a team that when you walked out next to them into that tunnel they were massive, these guys. You had Vieira, Petit, Adams, Keown, and after Campbell, Kolo, Gilberto, Henry, Bergkamp. They were monsters. A friend of mine who was responsible for French television used to come here and he said, "I looked at your team and the charisma they carry is unbelievable. It's not natural." They had the stature to say look at me, I know I am good. The opponents felt that as well.❜
Arsène

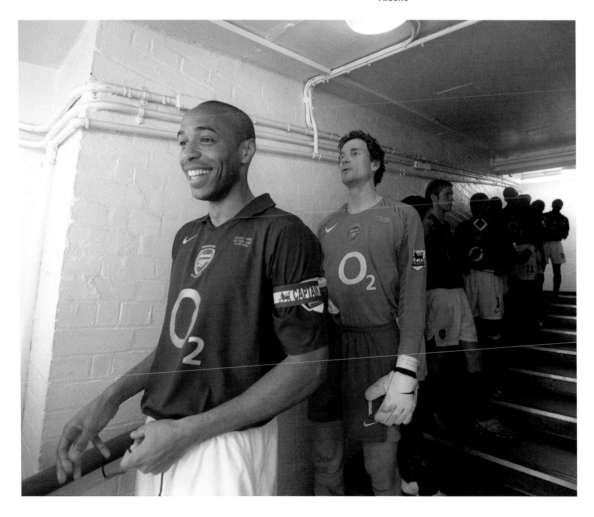

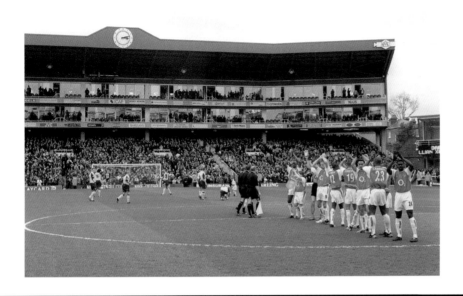

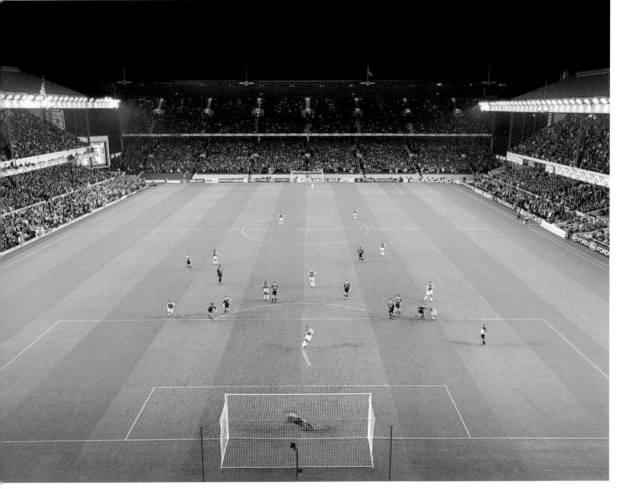

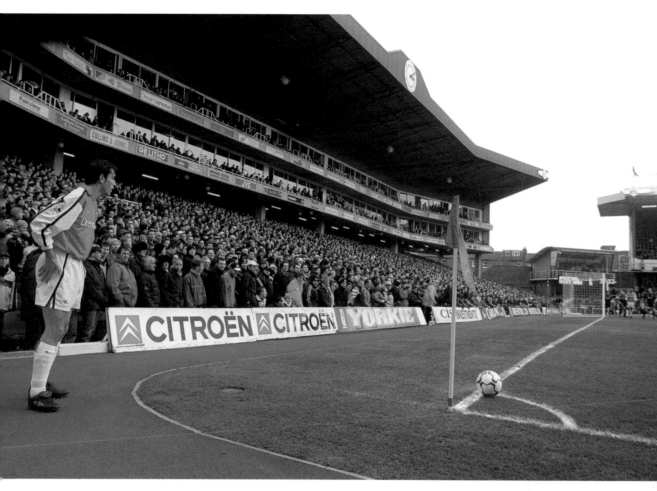

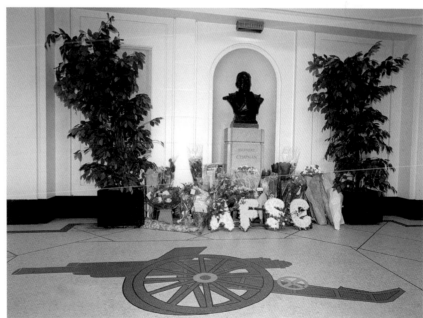

This was the Marble Halls after Arsenal lost a favourite son, David Rocastle. He would have been a perfect Wenger player.

One evening there was a beautiful sunset. Stuart grabbed his camera to go and have a look. This image is rich in symbolism of old and new, as the Emirates Stadium is in the background as the sun set at Highbury.

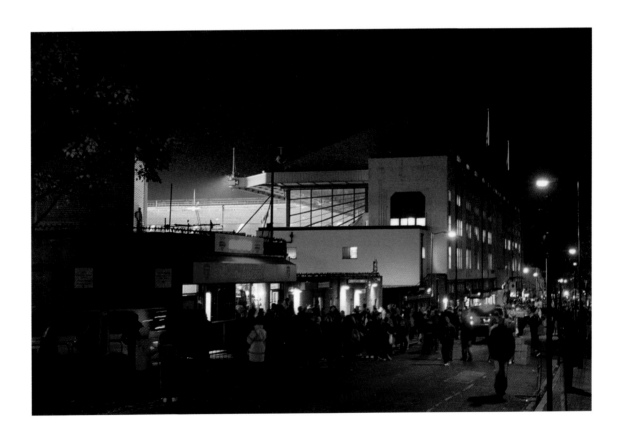

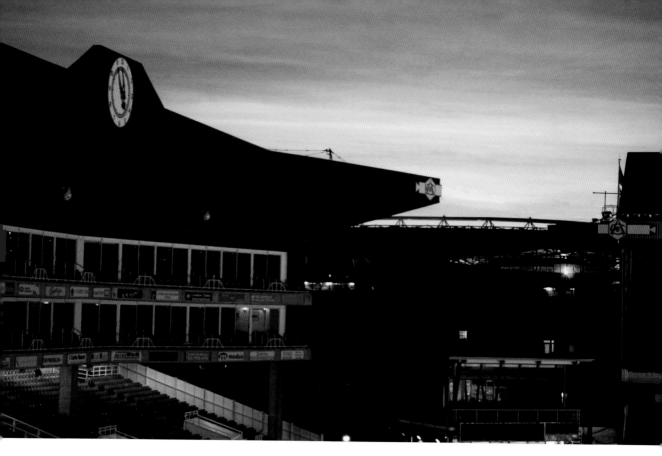

Highbury was as much about the people inside it. This man, Paddy, actually lived in the stadium. He only had boiling water in his flat in the West Stand, so he used to bath or shower every day in the first team dressing room. Everyone knew Paddy, and everyone loved him. He made people feel part of the furniture. His job was to look after the dressing room areas and make sure the team and staff had everything they needed.

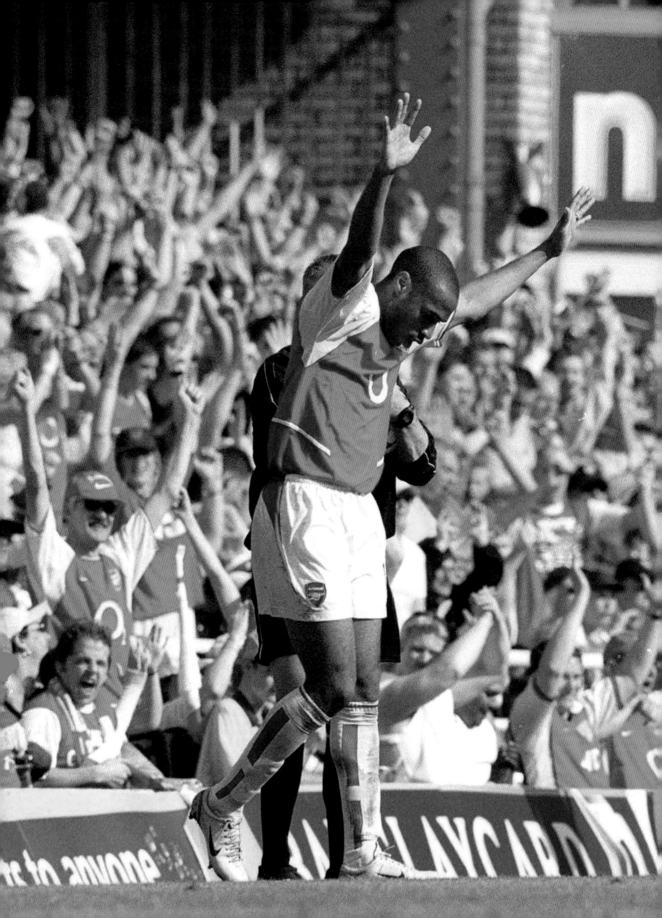

5

UNBEATABLE

‘This is the final whistle of the final game unbeaten. For me it was my life dream. You work in a job where you never really know how good you are, but I didn't think you can do more than go a whole season undefeated. To realize that life dream is a bit frightening, but it didn't kill my hunger.’
Arsène

To complete an unbeaten campaign, to produce an unblemished record, was an ideal that Wenger held dear since his own childhood. Such is the nature of competition – in particular in a team sport – where there are so many variables that can effect a single result, it felt to him like an attainment on a higher plane. It represents a success that is somehow pure. No losses. No slips. No moments of weakness.

The mere idea of an undefeated Premier League season was not something that was a driving force for Wenger's contemporaries simply because there was very little in the way of precedent. It had never been accomplished in the modern game, and only once in the history of English football, way back in 1888–89 by Preston North End during the country's inaugural league competition.

Unlike any of his peers, Wenger believed it was a genuine ambition worth pursuing. He reckoned he had a team capable of pulling off this most rare of feats. The idea grew once he observed how his team did not lose a single league fixture away from home in 2002. Why not go one better? The following autumn with his team still going strong, in a pre-match press conference at the training ground he told the assembled journalists that in his opinion, his team could go a season unbeaten. 'It is not impossible', he said.

He knew that people would think he was stating something ridiculous. The idea invited scorn there and then, which only multiplied when Arsenal lurched suddenly into a first defeat of the 2002–03 season. The critics who thought Wenger had been unnecessarily arrogant with his suggestion relished that loss.

At the end of the campaign, Arsenal won the FA Cup but missed out on another title by a handful of points. They felt they might have won the double again but were a fraction off. Wenger recalls the pre-season meeting for the 2003–04 season clearly. He wanted to discuss with his players why they thought they had fallen short of their main target, which was always the domestic title. 'When I asked them at the start of the following season why did we not win the league, they said maybe it's down to me because I put too much pressure on them to win the league without losing a game', he says. 'Yes, we could have achieved more. But you had other good teams in England as well. Let's not forget that Manchester United had a strong generation.'

Arsenal attacked the new campaign with renewed determination. There would be no more discussion about an unbeaten season. Not for a while anyway.

By Christmas, Arsenal were well placed in the hunt and hadn't lost a league match. By Easter, Arsenal were favourites for the title and still hadn't lost a league match. By April, they boarded the team bus for White Hart Lane knowing if they avoided defeat they would win the league in the lair of their local rivals. With a 2-2 draw, Arsenal became Champions without losing a single league match.

The unbeaten season was now, incontrovertibly, a very big deal. Here was a chance not just to win the most valuable prize in the domestic game, but to rewrite history. 'Make yourself immortal', Wenger told his players. 'Don't miss it.' There were four games remaining, all against teams with nothing riding on their fixtures against Arsenal (three were safe in mid-table and one already relegated).

Those games proved an unexpected ordeal, though, as the players relaxed after winning the league with games to spare. It was hard to generate the right levels of motivation and energy. 'The last four games were tricky, we just scraped through', recalls Wenger. 'Even in the last game we were 1-0 down.' It seems remarkable to think a team could go 37 out of 38 unbeaten and stand on the brink of ruining it. At half time of the final match against Leicester, they trailed. The team's outstanding will-to-win, and the class of some of its most individually talented components (Henry, who scored the equalizer, and Vieira and Bergkamp, who combined for the winner) made the difference. Wenger's lifelong dream was realized. His controversial prediction that it was possible, so mocked at the time, became a beautiful truth.

He does not think too many teams in future will be able to emulate that purity of the 2003–04 league campaign. 'The competition is harder today,' Wenger says. 'You have Man City, Man United, Chelsea, all the big teams. It will become tougher and tougher because the financial potential of other teams who are growing means even more clubs will have the same potential.'

Arsenal's Invincibles seized their moment to make history.

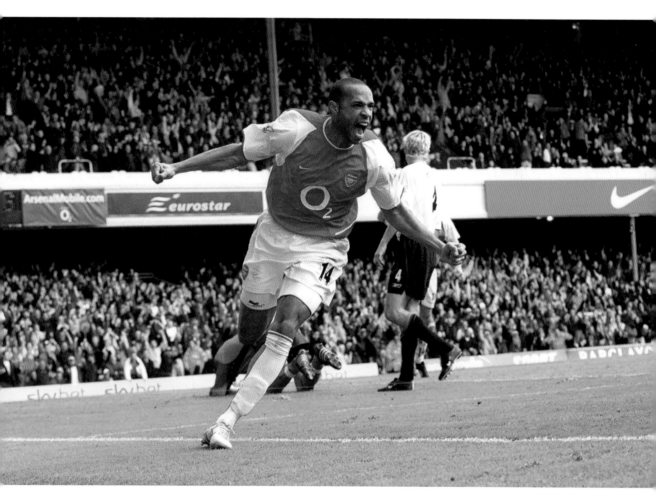

'Thierry Henry saved us. We were 2-1 down against Liverpool, having lost against Chelsea in the Champions League and Man United in the FA Cup in one week. We were wobbling. At half time the guys were absolutely speechless. We had not lost a game in the league but were not sure to win the Championship at that stage. Thierry sent Carragher to the stands to score a great goal. He was a super, super talent. He could do absolutely everything.'
Arsène

‘We drew 0-0 at Old Trafford in an emotional game. They were amazing battles in those days. You are hoping the damage will not be too big. Look how Man United had Ronaldo, Roy Keane, van Nistelrooy. It was a fight. But we had fighters of our own. Lauren and Ashley Cole were not the last ones to fight. Ashley was not a massive guy but he was a real fighter. Lauren was a top fighter. A real boxer! You notice the strong personalities.’
Arsène

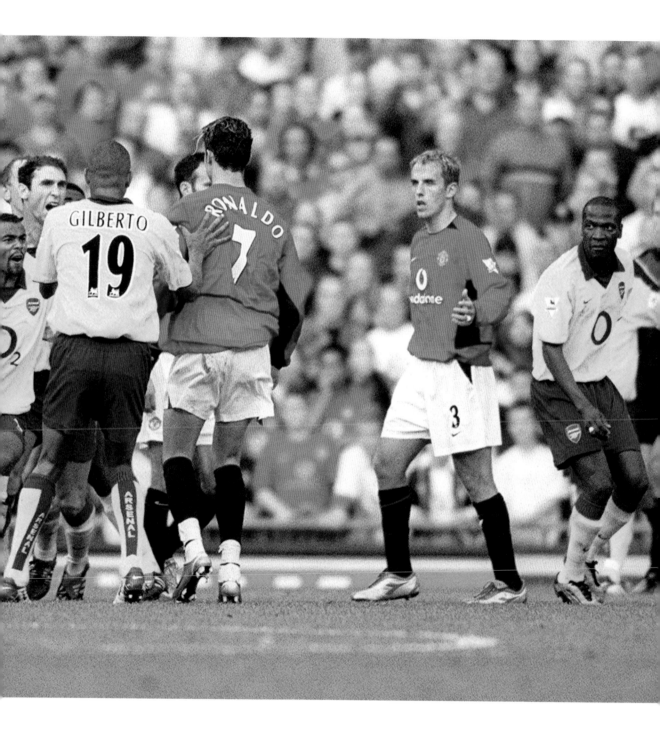

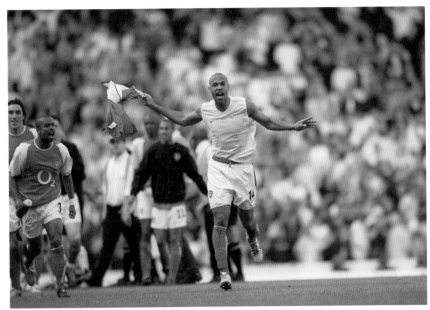

‘To win the league at White Hart Lane was exceptional. Even though we conceded a penalty in the last minute and Jens Lehmann and Sol Campbell nearly had a fight because Tottenham got a penalty to make a draw! We knew what we had to do. That was the title right there in front of us.’
Arsène

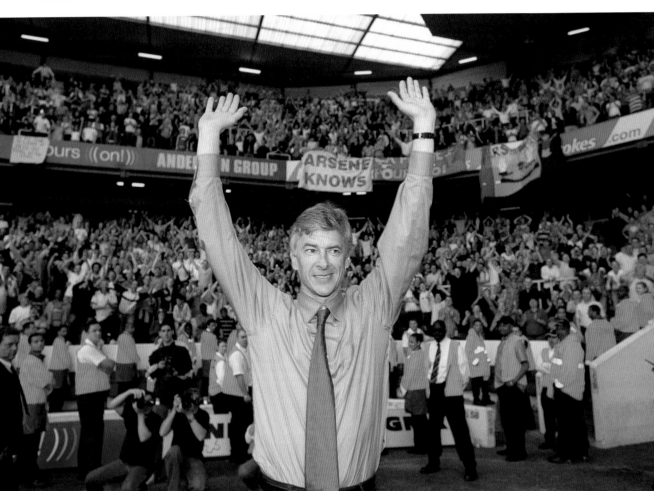

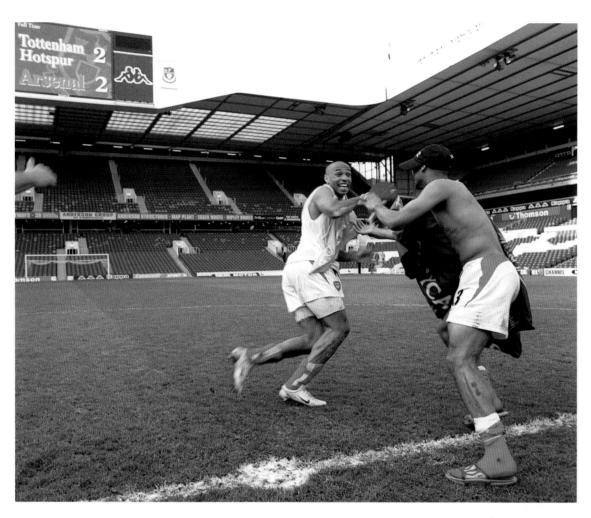

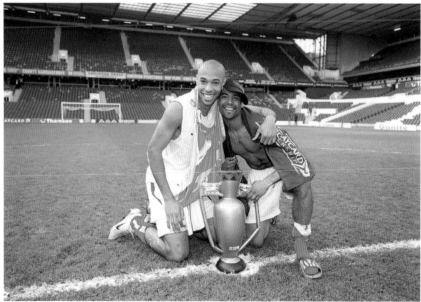

The players were celebrating in front of the fans in the visiting corner and one of them noticed a kid with a plastic inflatable trophy. Having spotted it they asked Stuart to go to get it. He climbed into the stand and this plastic trophy was passed down to give to the players. Ashley and Thierry took it to plant on the centre spot.

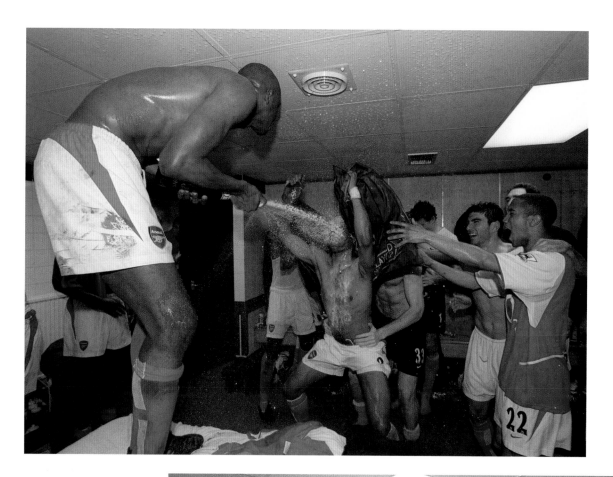

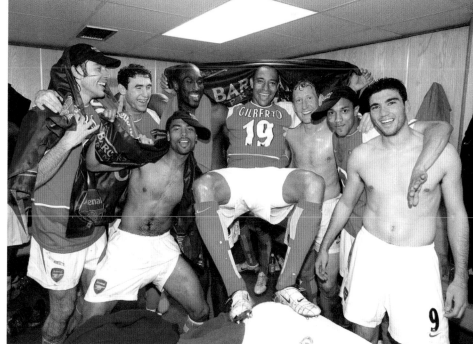

‘Look how happy they are together in the dressing room after the game. Like always when you win the league you switch off. I told them, "Now you can become immortal. Don't miss it."’
Arsène

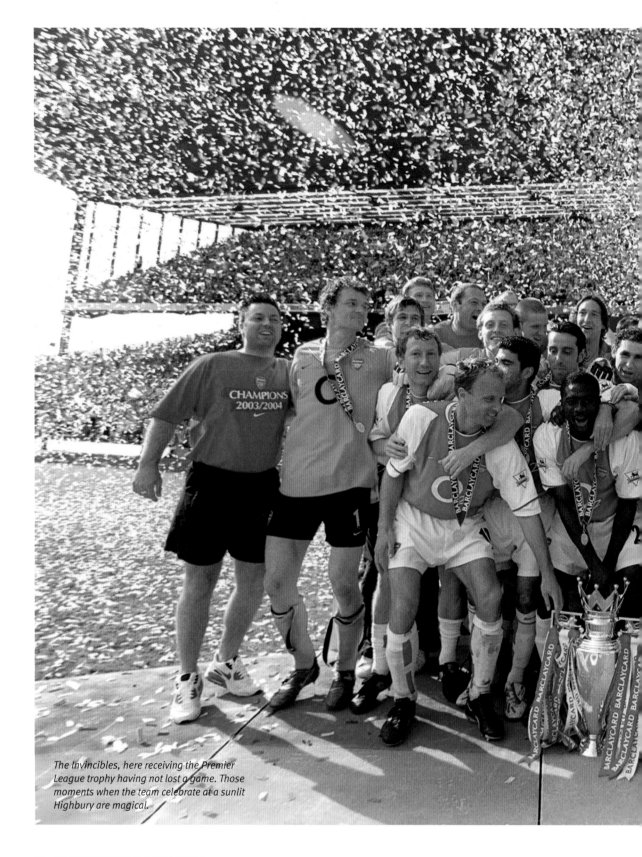

The Invincibles, here receiving the Premier
League trophy having not lost a game. Those
moments when the team celebrate at a sunlit
Highbury are magical.

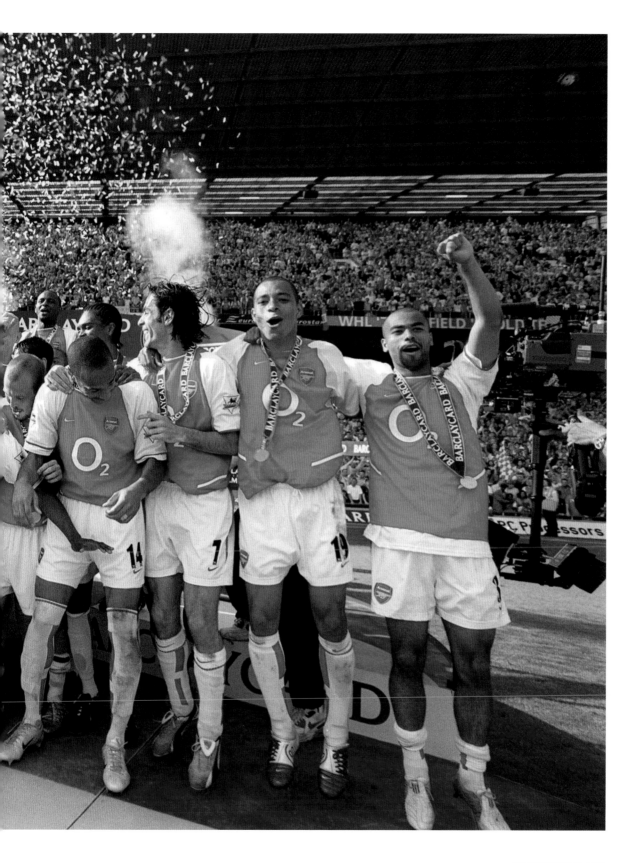

Martin Keown needed one more appearance to qualify for a medal and was desperate to get on. Ray Parlour warmed up as the last sub just to wind Martin up. Seeing Arsène, who by now is in on the joke, enjoying the situation is remarkable. It's not often a manager can laugh by the side of the pitch during a match.

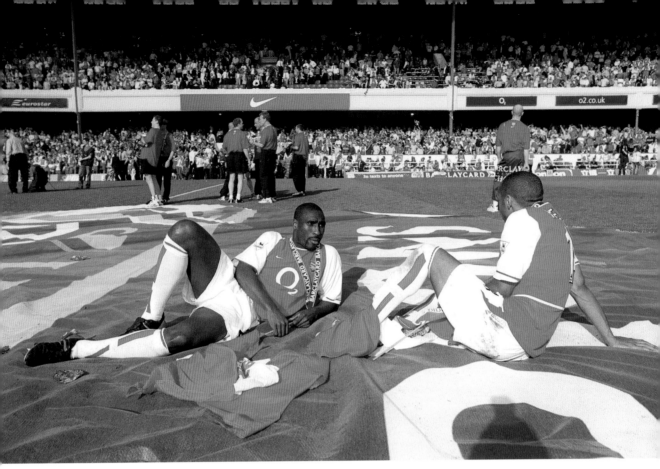

The trophy was being shown off to the crowd by the players taking it round the pitch, but Thierry and Sol broke off to sit in the centre circle and try to take in the magnitude of the moment.

Jens thought he could take the trophy home. He said, 'That's what we do in Germany.'

During the celebrations this T-shirt flew on to the pitch and the boss went over to pick it up. Originally the T-shirt mocked the idea he predicted Arsenal could go the season unbeaten, so it was somehow a perfect prop.

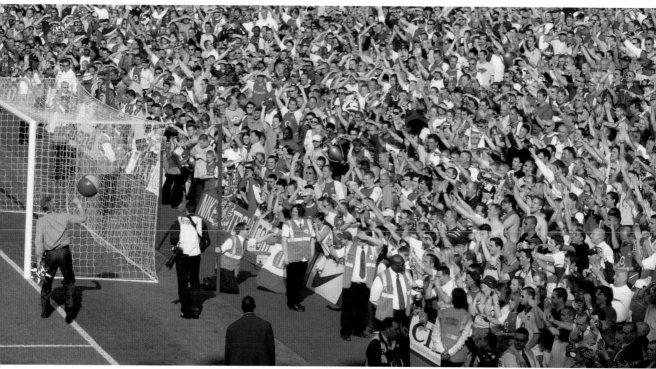

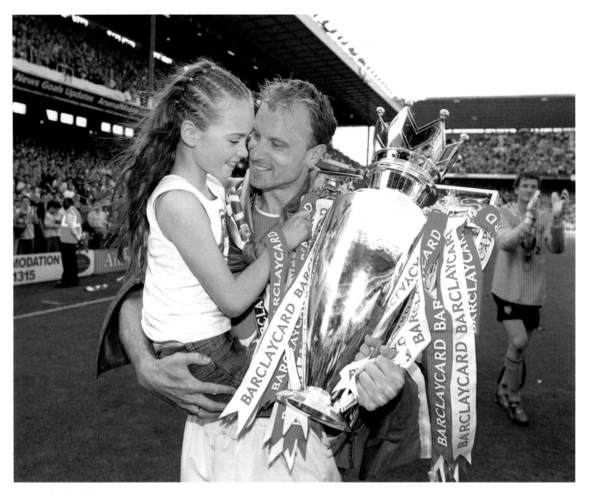

Football was getting bigger and bigger, but still at that stage Arsenal at Highbury felt like a family. The players and their families felt that as well.

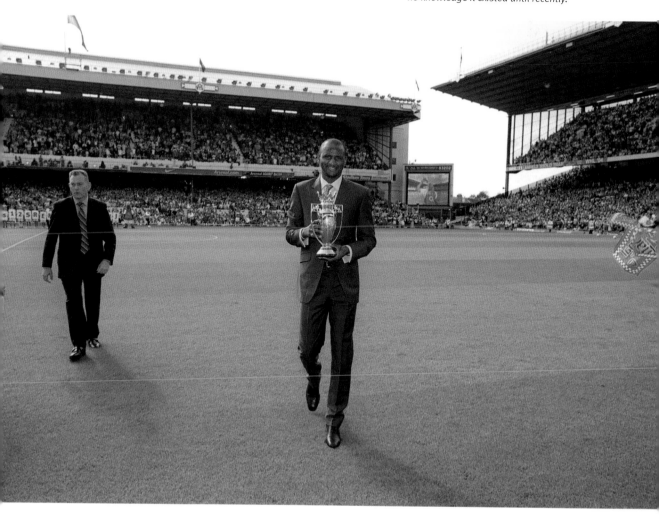

This is the first game of the following 2004–05 season. The Premier League had commissioned a gold edition of the trophy to commemorate the unbeaten achievement. All the other players were in the dressing room getting ready and Patrick turned out to be the only player to actually see this trophy. Some of them even had no knowledge it existed until recently.

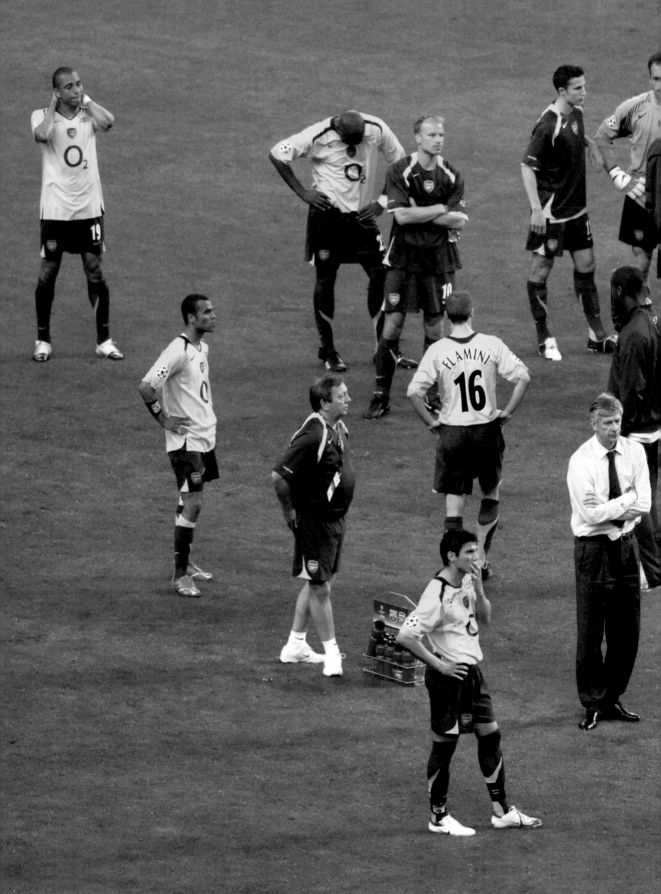

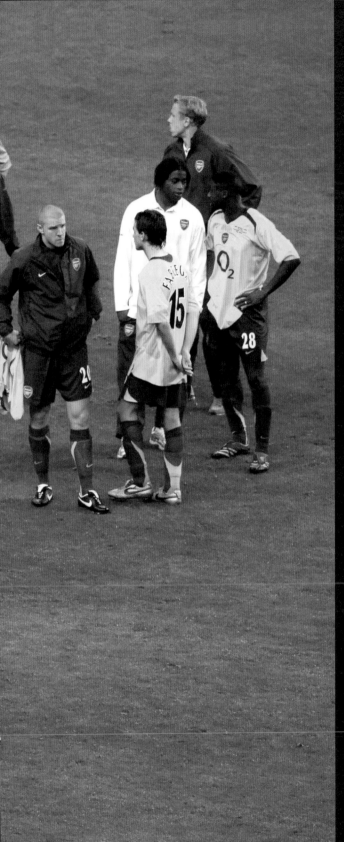

6

END OF
AN ERA

'The 2006 Champions League final
is my biggest regret of course. I feel
there was not that much in it. I have
thought to myself 100 times what
could I have done differently? Should
I have changed Cesc or not? Should I
have put on Flamini or not? Should I
have put Eboué on the right side of
midfield? You know when you are 1-0
up against Barcelona and you have
played for 70 minutes with 10 men that
the last 20 minutes will be difficult.
The regret on the night is more that we
could not get the second goal. Thierry
Henry, who has been magic for our
club, had the opportunity to do that.
After the game I spoke to our former
player Gio van Bronckhorst, who had
moved to Barcelona. He told me, "If you
had scored the second goal we would
have given up." So that is of course the
regret of my life. We were 13 minutes
away from winning the biggest trophy.
Maybe I will have to die with that – but
it will still hurt.'
Arsène

The Invincibles season was bookmarked by FA Cup wins. The overall picture reveals the most consistent winning period of the Wenger era, with trophies to hoist for four seasons in a row. Between 2002 and 2005, Arsenal won the league twice, and the FA Cup three times.

Cup finals essentially boil down to which side of the emotional fence you land at the final whistle. The visuals that accompany that moment at cup finals accentuate that visceral contrast. Winners wheel off in elation. Losers slump to the turf shattered. Arsenal may not look back at the FA Cup finals of 2003 and 2005 with much joy about the performances, but the results were to be cherished. In 2003 a sluggish final against Southampton was won by a decisive moment from Robert Pires. In 2005 Arsenal withstood pressure inflicted by a Manchester United side that was superior on the day, didn't play their best, but reserved a display of courage and precision for the penalty shoot out. The level of accuracy in these high-intensity kicks was brilliant. Jens Lehmann managed to keep United out once, and Arsenal's shots were unerringly perfect.

The scorer of the winning penalty was Patrick Vieira, the captain and midfield colossus who had been such a significant presence throughout the Wenger era up to that point. Although nobody knew it at the time, it would be his final kick for Arsenal. That summer, he departed for Serie A. Over the next couple of years the Invincible team would begin to break up quite quickly as Wenger looked to create a new group based around a younger, homegrown nucleus.

The other big clue from that match that suggests changes would be afoot is the way Wenger approached that Cup Final with unusual caution. He was wary of Manchester United that day and adjusted his team accordingly to play in a more defensive way than normal. It suggested he didn't feel confident enough to go toe-to-toe against the team that had been their biggest rival on the field for several successive years. That was very out of character.

It hints at an awareness that things would be changing, that the dynamic between Wenger's team and those around them would start to shift. Arsenal were preparing for a major upheaval – the departure from their ancestral home at Highbury for the modern and spacious stadium being built around the corner. A period of belt tightening was needed and without saying it out loud at the time, Wenger knew that this would be a challenging period for a team that would face a transition in terms of playing personnel and the broader identity.

The reinvention from Invincibles to Project Youth did not happen overnight. It was gradual. But the signs were there. Arsenal still had an abundance of experienced talent going into their last season at Highbury. But they added an injection of promising youth in the shape of Cesc Fàbregas, Mathieu Flamini and Philippe Senderos. During that campaign Wenger invested in the future, notably with the arrivals of Theo Walcott, Abou Diaby and Alex Song.

They came at a momentous time. That last dance at Highbury was profoundly emotional, and the club were simultaneously swept along by an enthralling run in Europe all the way to the Champions League Final. Arsenal defeated the establishment, beating Juventus and Real Madrid en route to a final in Paris against Barcelona.

Wenger remembers the details vividly, and with a salty-sweet mixture of affection for the team and pain for going so close. Some elements of that run were miraculous. 'For a long time we did not concede a goal, with a defence of Emmanuel Eboué, Philippe Senderos, Mathieu Flamini ... And we played against Real Madrid with Ronaldo, Zidane, Beckham, Raul!' he exclaims.

The drama of a stoppage-time penalty save in the semi-final at Villarreal opened the gateway to the final. Arsenal were the unlikely finalists, a team that had a patchwork defence, a newly styled midfield blending old nous and new energy, and Henry up front. It wasn't a team that had the obvious strengths of previous title winners (they only scraped fourth place in the Premier League that year) but they had an impressive conviction and crest-of-a-wave enthusiasm that drove them on.

In the final, the capacity to push Barcelona with ten men after Lehmann's dismissal required immense effort. But Arsenal were left vanquished. 'It is my biggest regret', Wenger says. To this day, he asks himself if he might have done things differently to provoke a happier outcome.

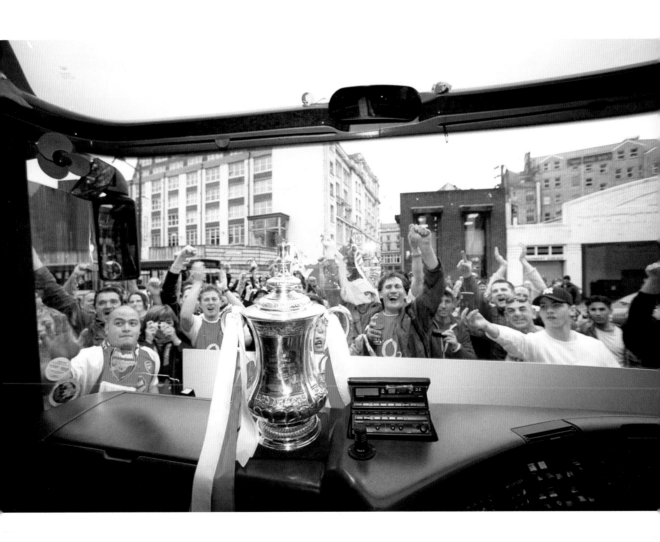

After winning the 2003 FA Cup final, leaving the stadium with the FA Cup on the front of the bus was amazing. At Cardiff there are loads of bars close by and all the fans were not short of enthusiasm as they waited to see the team off.

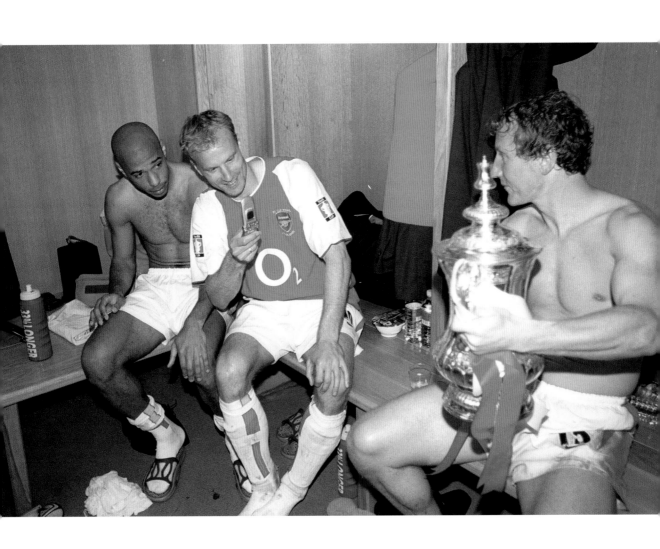

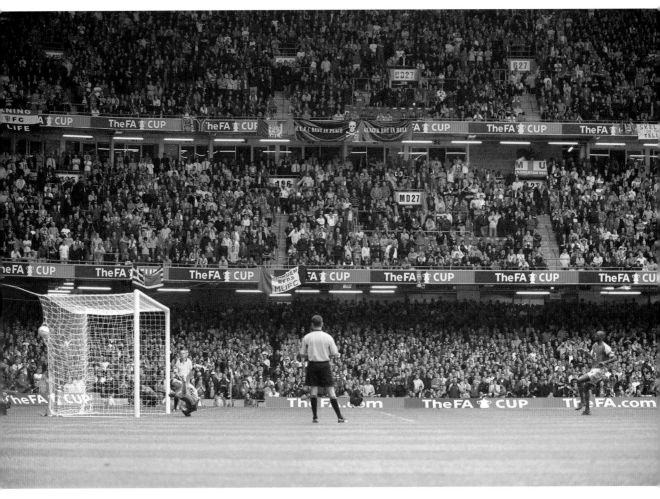

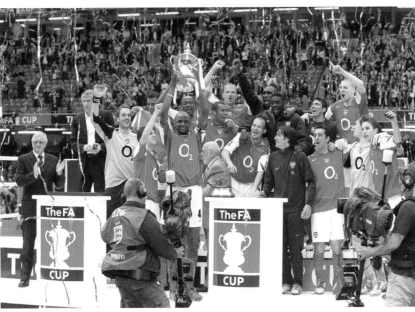

'This was Patrick Vieira's last kick for Arsenal. It nearly makes me cry. Sometimes you have the moment where big figures of the club have to go. It's a sad moment and a happy moment. Somewhere you could feel in that game things were changing. We won this final in 2005, but we should have lost it 10 times.'
Arsène

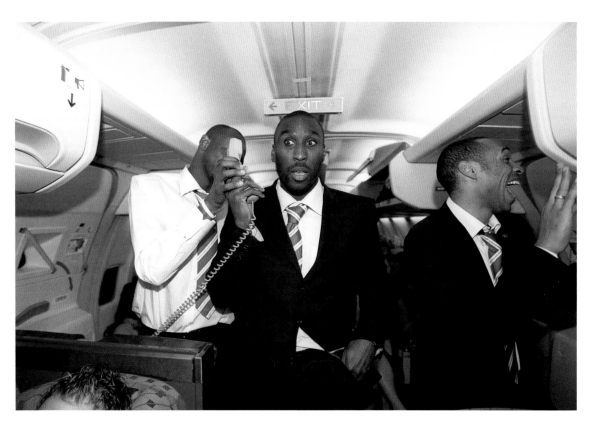

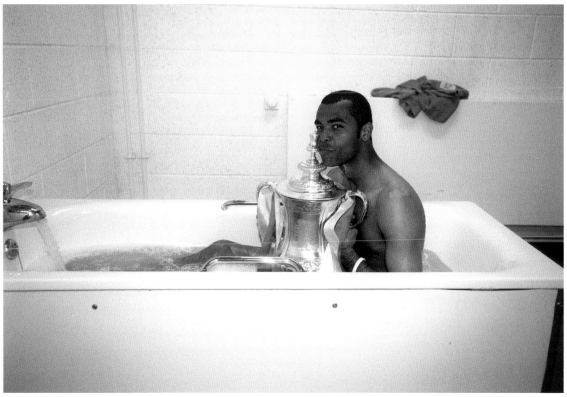

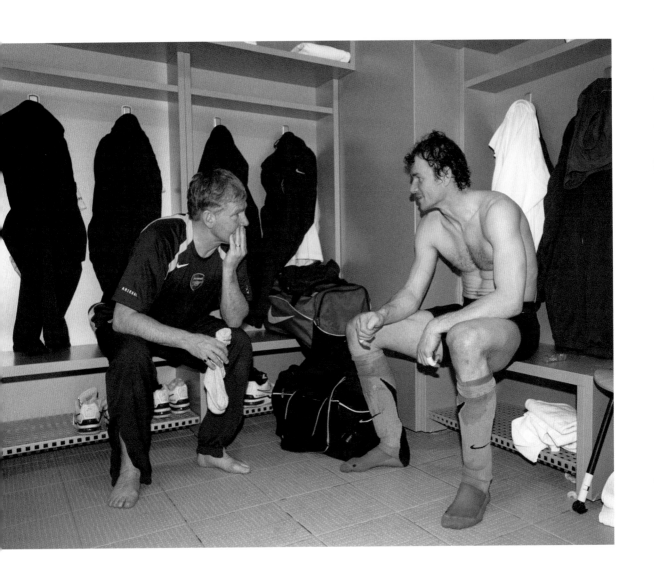

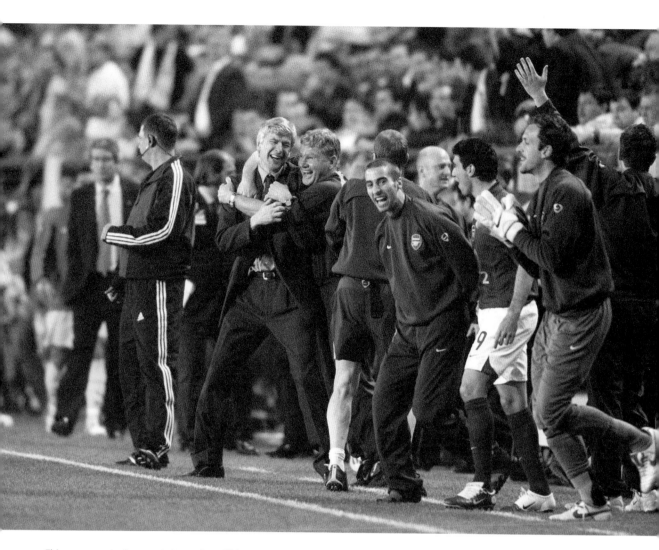

*This was a seminal moment, Arsenal qualifying
for the Champions League Final for the first time
by beating Villarreal. Jens Lehmann was the
hero with a last-minute penalty save.*

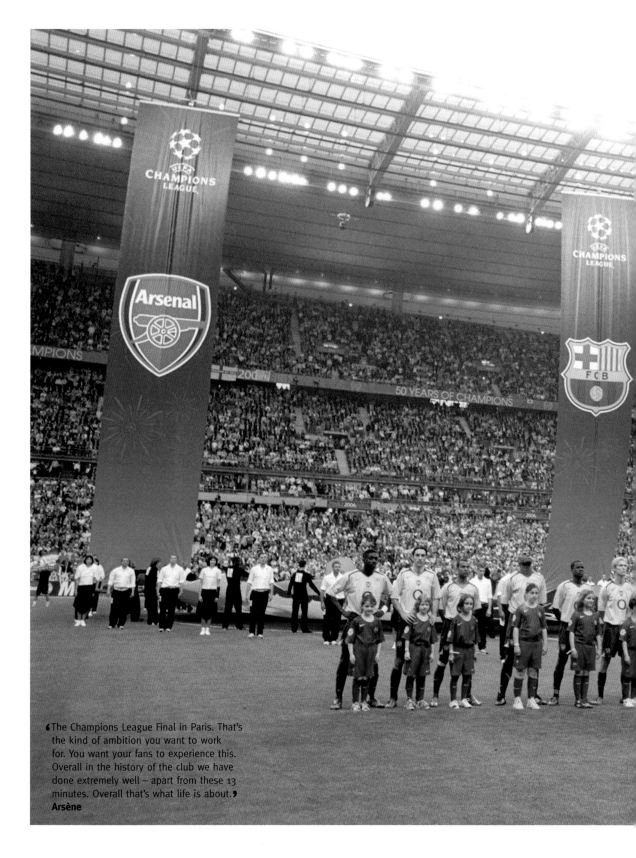

'The Champions League Final in Paris. That's the kind of ambition you want to work for. You want your fans to experience this. Overall in the history of the club we have done extremely well – apart from these 13 minutes. Overall that's what life is about.'
Arsène

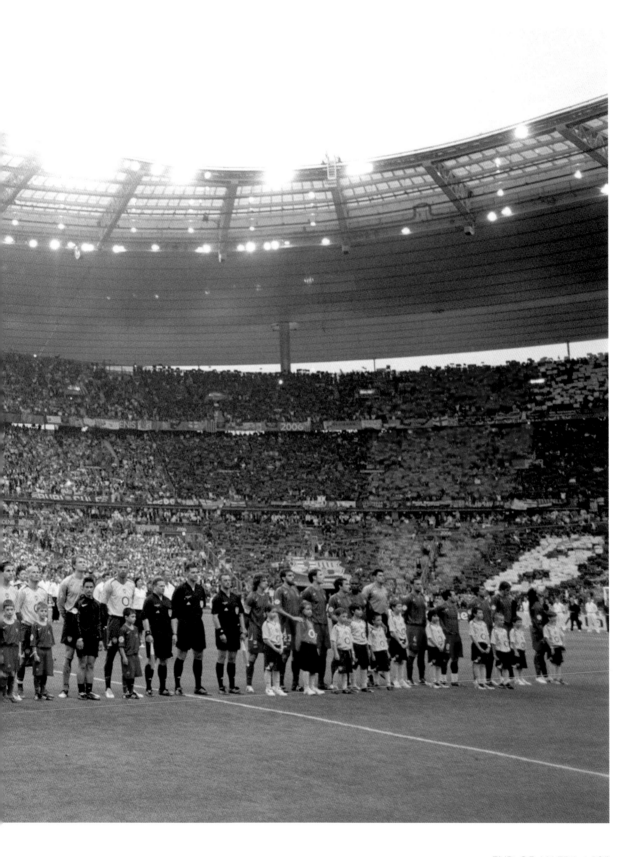

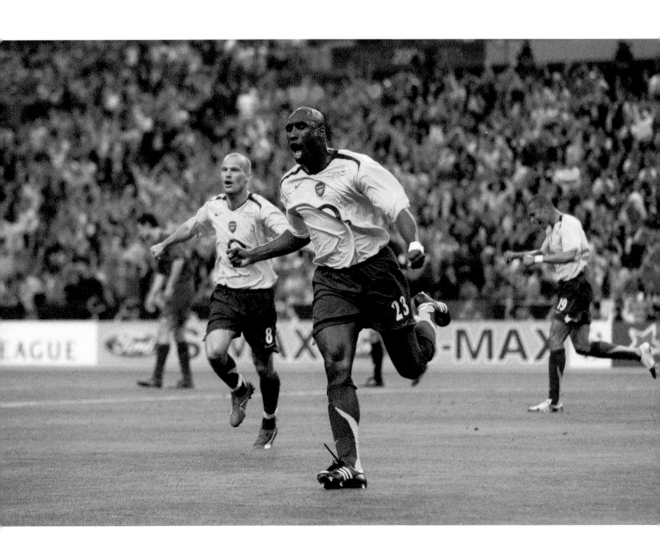

'You learn from your defeats but you also learn from your victories. You are more able to learn from defeats because it hurts. It is more natural.'
Arsène

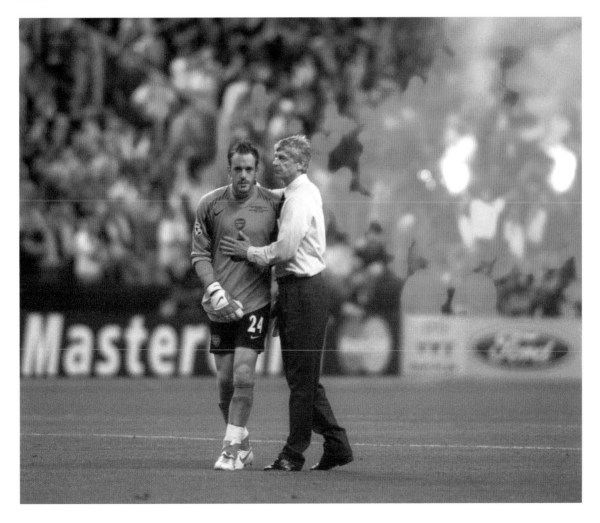

7

BRAVE
NEW
WORLD

‘What I like about Arsenal, and what
I am very proud of, is that the club
is a mixture of respecting traditional
values while also not being scared to
move forward.’
Arsène

Two giant bridges, wide enough to be motorways, carry Arsenal fans over the railway lines that split the Emirates Stadium from an adjacent road, Drayton Park. They are named after men who never kicked a ball for Arsenal. But their influence overseeing one of the biggest tasks in the club's evolution is enormous. Danny Fiszman, who was a key figure on the board for almost 20 years, and Ken Friar, who worked around the place since boyhood and became a respected administrator, dedicated several years of their lives to the project which ensured Arsenal's future home would remain in its Islington heartland.

The move was a dominating factor behind the scenes for the best part of a decade. That is how long it took from those pivotal meetings when the board agreed they would look for a site for a new stadium to the opening fixture at the Emirates in July 2006. From conception to completion, more than 2,500 legal documents were signed to give the project clearance.

The process was very demanding. First of all Arsenal had to weigh up actually leaving Highbury in the first place, and loosening ties with the place that was such a big part of their identity. The decision took on a feeling of inevitability as plans to expand Highbury, which was closed in by residential streets and had limited prospects for any extension, were complex and not big enough for what the club had in mind.

Finding a suitable plot of land was a thorny challenge and Arsenal had to consider all sorts of possibilities – undeveloped land behind Kings Cross, a share at Wembley and even a relocation somewhere near the M25. With incredible luck, a local property adviser found a spot right on their doorstep, a mere 500 yards from Highbury.

It was encouraging, but there were still huge obstacles to overcome. There were battles to be won with Islington Council, local residents and businesses. This move didn't just involve the construction of a new stadium, but an assortment of other building works and urban regeneration schemes on land that hardly comes cheap in London. The Emirates was built on the site of Islington Council's old waste disposal unit so a new one was built. The proceeds from building several housing developments in the vicinity contributed part of the funding. Highbury itself

was redeveloped into flats, with the listed façades of the East and West Stands protected, and the old pitch retained as a central garden.

In terms of finance, Arsenal needed to account for a ballpark of £400 million for the entire project. For a football club a mission on this scale was more or less unprecedented. As Wenger reflects on the supersized work required to see this through, he sounds amazed Arsenal's board ever made it happen. 'It was nearly unbelievable', he concludes.

Construction work finally began in February 2004, just as the team on the pitch were coming towards the climax of the Invincible season. The first seat was ceremonially installed just over two years later. In July 2006 the team officially moved in, playing their first match in their new stadium against Ajax to celebrate Dennis Bergkamp's testimonial.

But how to make it feel like home? That was another task in itself. 'Arsenalisation' was the word chosen by the club for the new project to add visible references around the place to bring a much needed sense of personality to a smart contemporary bowl. Supersized murals of legendary players decorate the exterior, and inside, images depicting the club's history are prevalent.

A few nods to Highbury were essential. They managed to transport the famous oak pannelling from the old boardroom across to the new offices, and there is a time capsule including 40 symbols of the old ground such as a piece of the old turf, a record of all matches played there, every home shirt they played in, match tickets and a video of the club history, which the players pass at their entrance whenever they come in and out on matchday. As a place of work, they have more space and facilities than was ever possible at Highbury to prepare pre-match and wind down post-match. Of course Wenger had a say in a few key touches of the design. The home dressing room originally had a supporting pillar right in the middle of it. Naturally it had to go, as the manager deems it essential that everyone in the squad can have eye contact with each other in that most crucial area.

'I felt for a long time not completely at home. That we had to create our history again', Wenger explains. Time, and a trophy earned and celebrated there, were needed to truly begin that process.

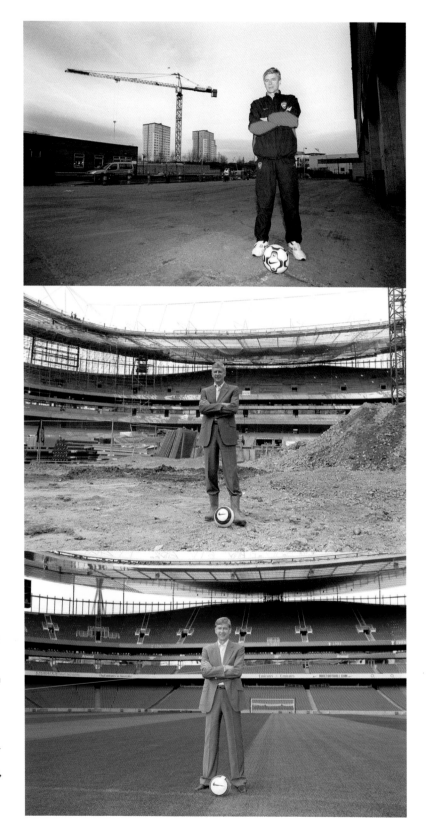

'I remember we took the first photos at the Emirates while the lorries still came in to bring the rubbish in to the old waste recycling unit they had there. We built one stand first, and we made photos from the top of that stand with the lorries still going past in the background. In all three pictures I am standing on the position of the centre spot. Of course we were scared for a long time, we didn't know if we could open without delays. We didn't know what we would discover. First we did the stands, and after the pitch, and that went quite well.'
Arsène

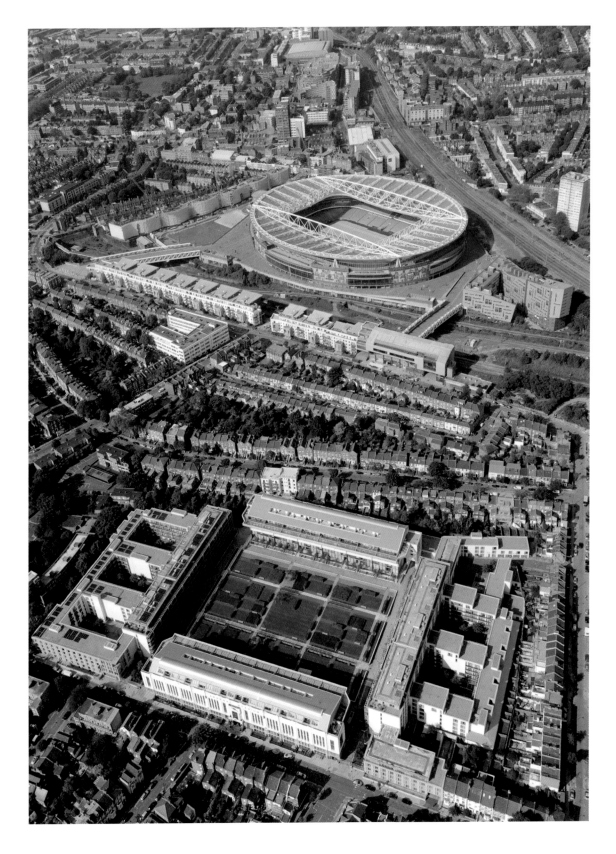

'That is the photo that shows you the luck we had to go from one to the other. For me that was a big problem. We looked at the M25, but to move all these people out by car for matches would have been a nightmare. We looked at Kings Cross. But this was even better. We were able to stay in our heartland. It worked in a smooth way. Ken Friar and Danny Fiszman did an exceptional job in relocating all the businesses and sorting the problems out with the banks as we had to borrow so much money. It was nearly unthinkable.'
Arsène

The club worked hard to turn the Emirates from an empty shell into somewhere that felt like home and had an identity.

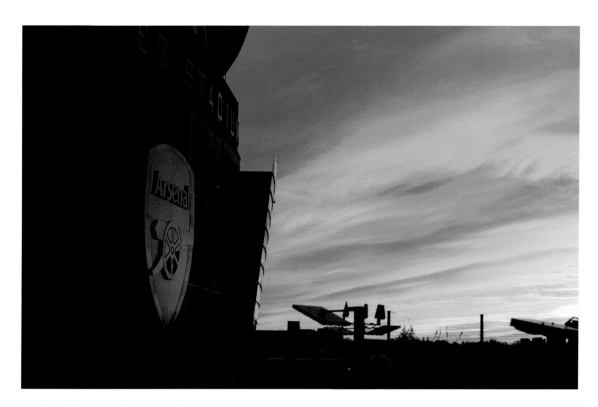

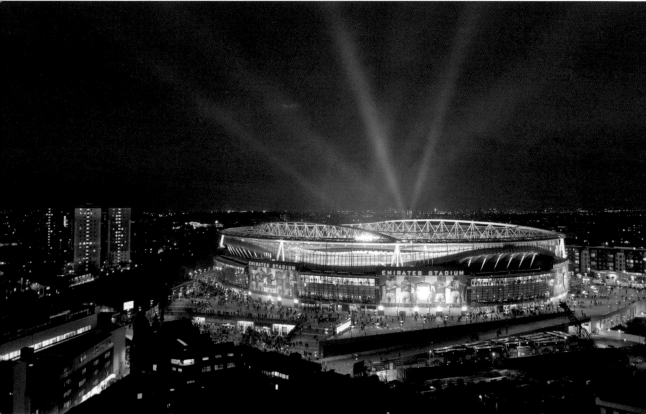

‘I always go to check the pitch on the morning of the game. It is to see how short they cut the grass, how quick the pitch will be, how good the surface is. You want to know that when you are a football man. That picture seems to show the loneliness of my job. Because sometimes the guy you see there, that guy still has some doubts in his mind to know what kind of team he will play. Most of the time he had not a very good night, and is still wondering what he wants to do for the game.’
Arsène

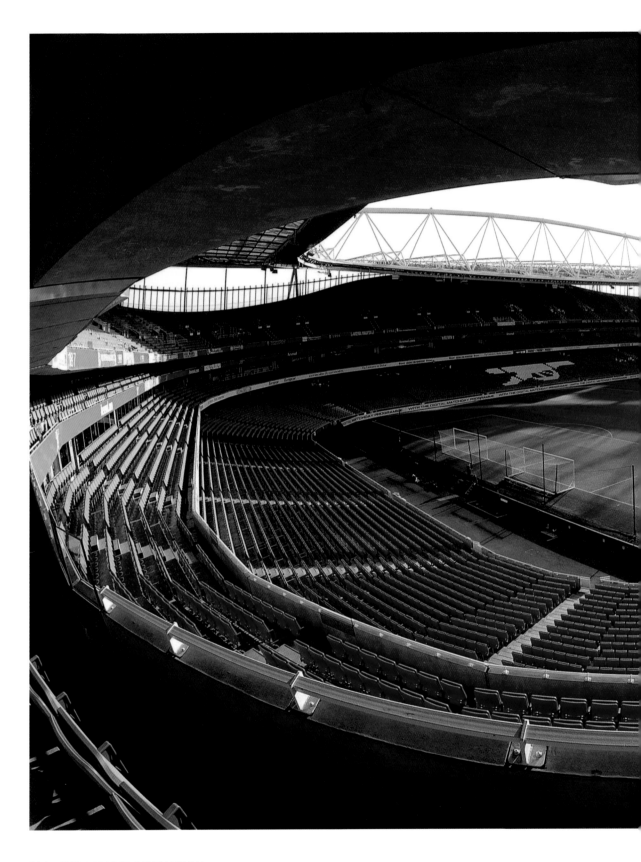

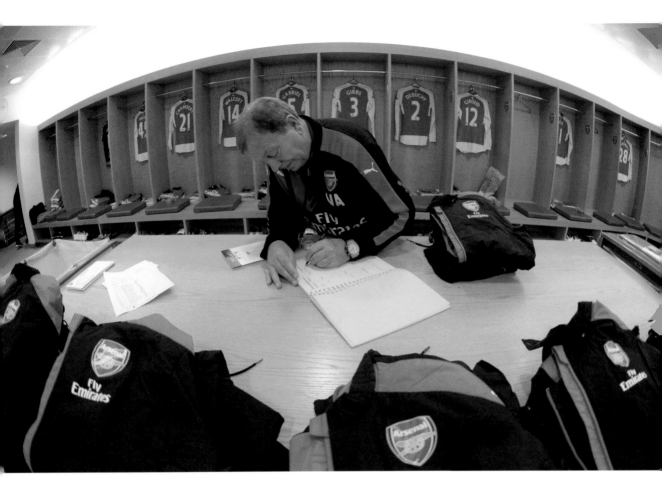

'Everything is prepared in the home
 dressing room before a game.'
 Arsène

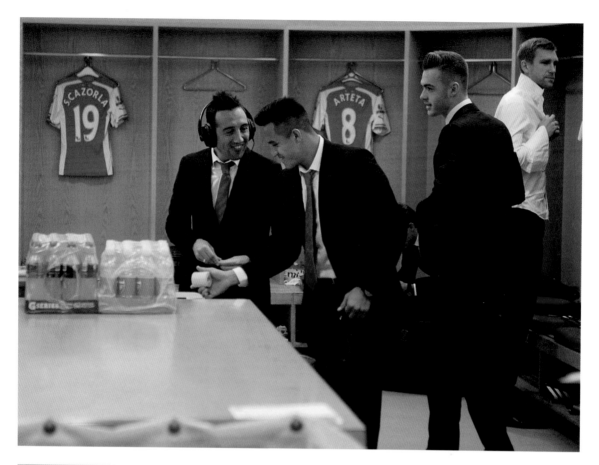

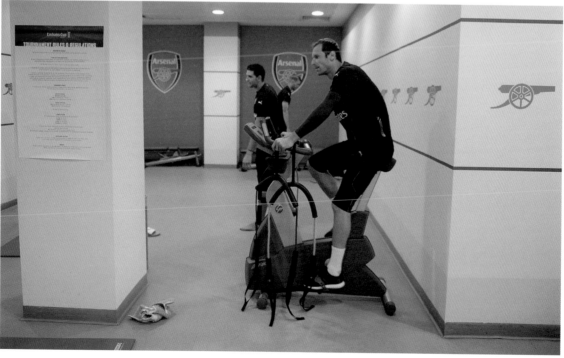

That moment shows the bond between the players and the staff, they come and hug our kit man, Vic, before going onto the pitch.

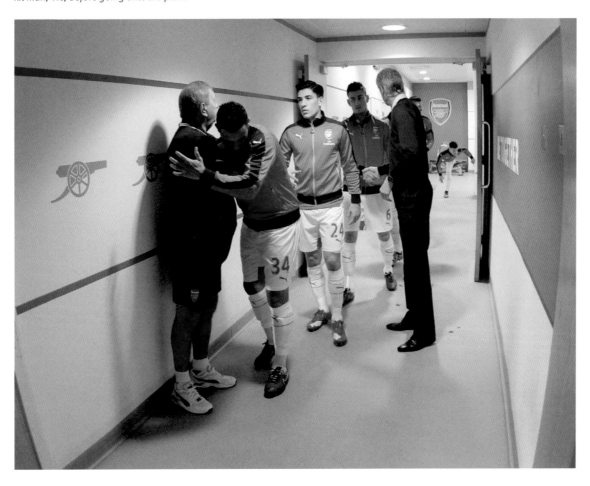

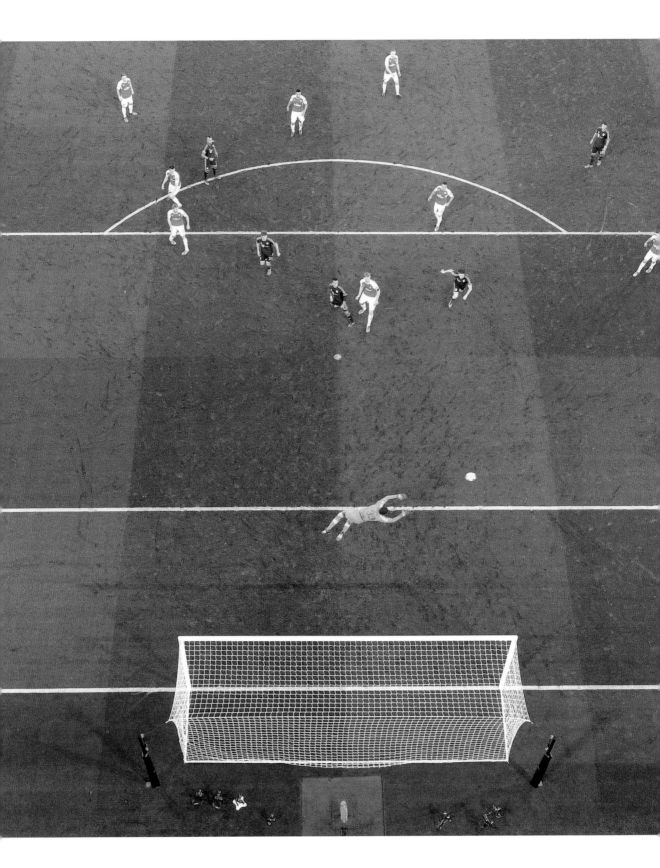

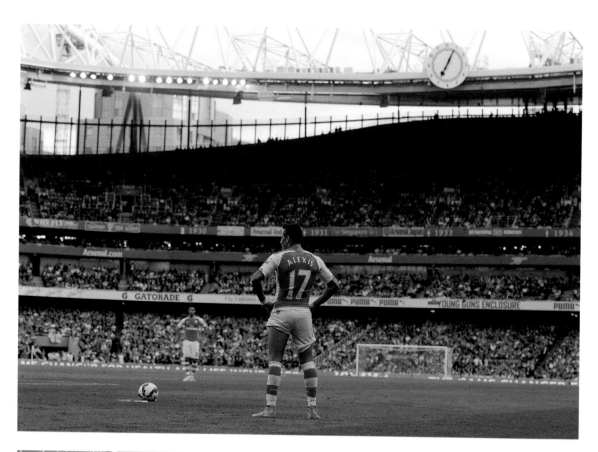

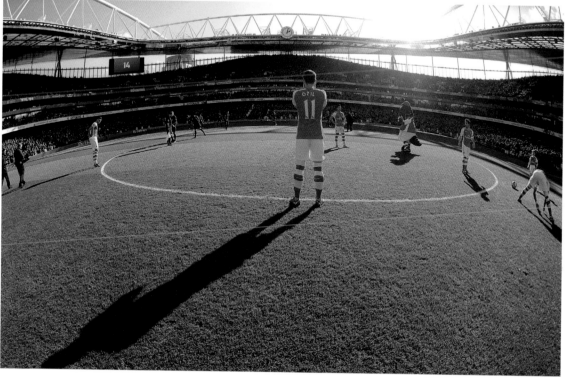

'I felt for a long time not completely at home. That we had to create our history again. In the first few years after moving to the Emirates I feel we were remarkably consistent, even though we were questioned.'
Arsène

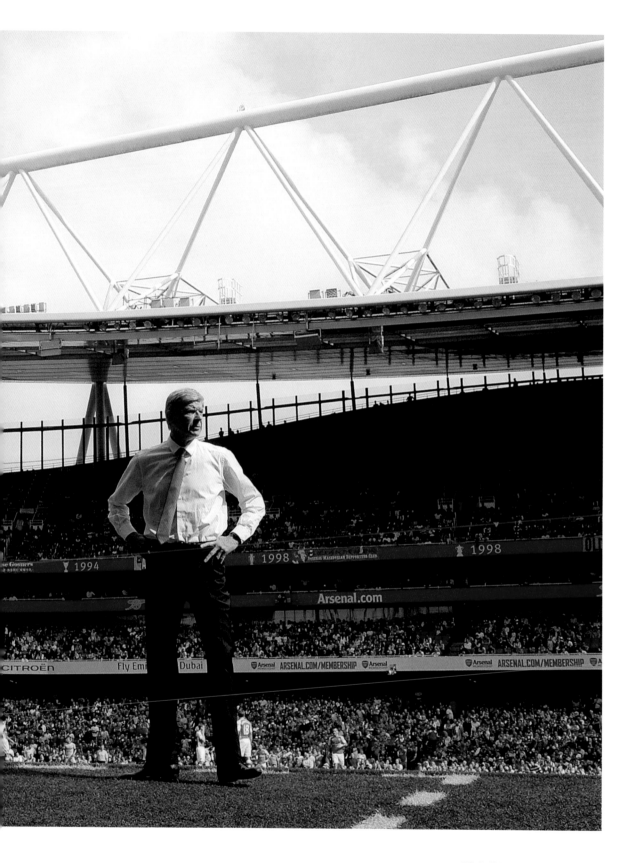

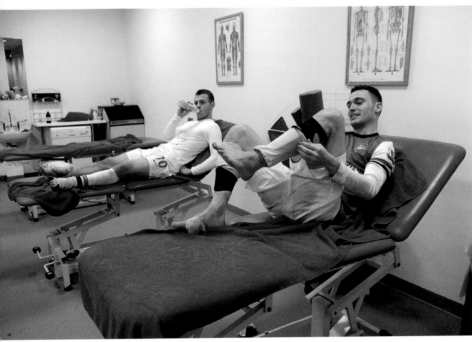

Post-match. Jack Wilshere, back in the medical room, ices his ankle after a game. He played the game wearing a T-shirt saying 'Happy Birthday Mum!' under his kit.

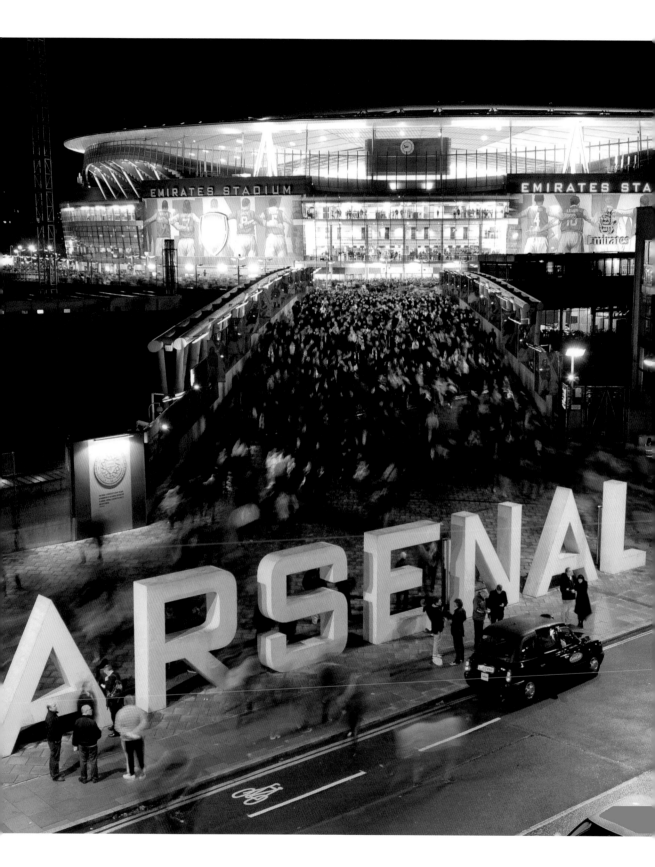

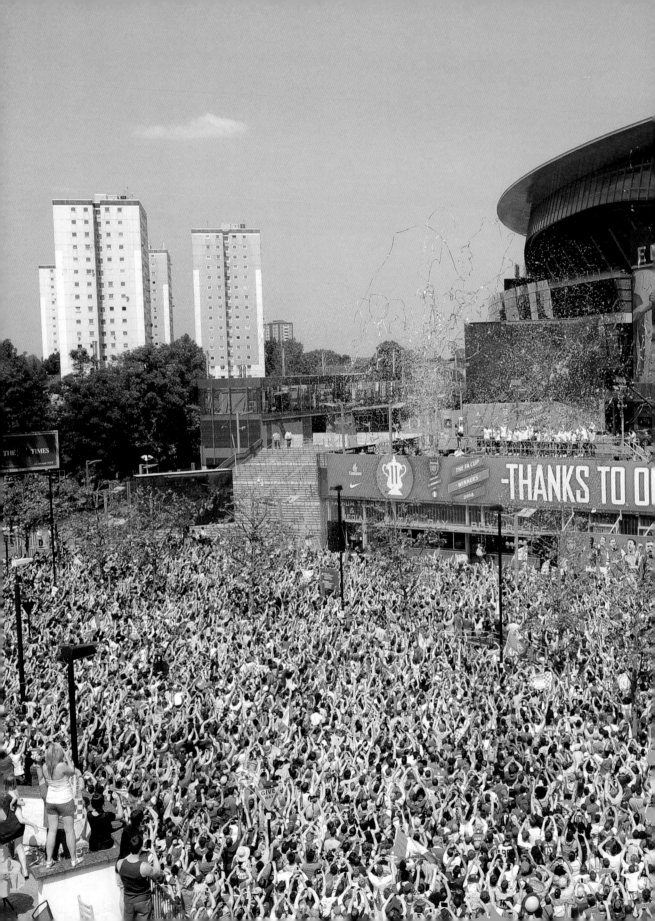

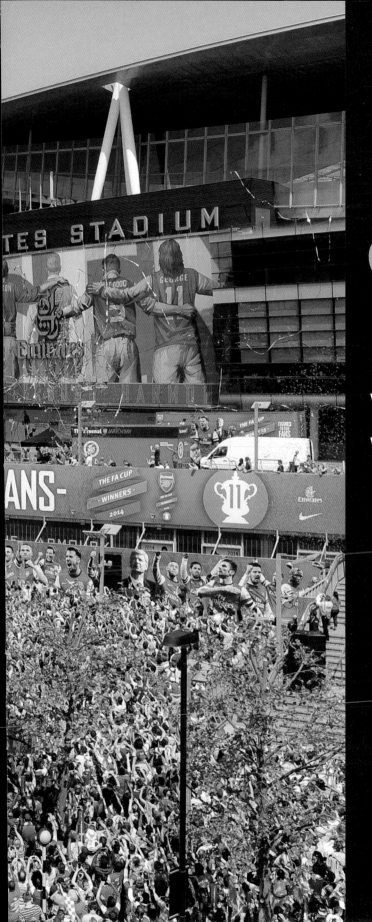

8

BACK TO WINNING WAYS

‘Winning this FA Cup was an
important moment in the life of
this team. When it comes after a
long time it sometimes comes with
suffering. We had such a feeling of
relief and happiness.’
Arsène

Departing Cardiff's Millennium Stadium in 2005 with the FA Cup and triumphant smiles, Arsenal's seventh trophy in an eight year cluster, there was no foreboding sense that the club would have to wait the best part of a decade for that winning feeling again. Success does not feel transient when you are in the midst of it.

Within the club there was awareness that they were heading into a complex period, where they would have to operate with restricted finances as they left Highbury and paid for their expensive move. But as far as the board were concerned, if there was one man they trusted implicitly to guide them through their temporary age of austerity it was the manager they had in situ. Faith in Arsène Wenger was absolute.

He had prepared as rationally as he could. Arsenal would be cautious and careful in the transfer market and hope to build around young players. 'Of course, it's not all down to money. But if you want to be successful it's better you have it', he said with typical candour.

The problem for Arsenal, though, was that the best-laid plans got frayed by influences outside of their control. Away from the pitch there was a property crash, which threatened the extensive programme to repay what they borrowed to build the Emirates Stadium. On the pitch they suddenly had to contend with a football scene being redrawn by oligarchs and petro-dollars. Roman Abramovich arrived to fund lavish improvements at Chelsea. Before long, Manchester City followed a similar path.

Wenger's commitment to young players felt exposed at a time when rivals were able to recruit heavyweight experience. The difficulties that posed were symbolized by the 2007 League Cup final. It was Arsenal's young guns against the Premier League champions Chelsea. The contrast between the two line-ups was stark. Wenger picked an emphatically youthful side full of promise. José Mourinho's team was packed with established stars.

Competing at the highest level during this period was a challenge. Each season that passed without a trophy was totted up and thrown at Wenger. Against a struggling Birmingham team that would be relegated that season, Arsenal were favourites in the 2011 League Cup final. They blundered. These were brutal lessons for Wenger's young players.

Was it hard to trust youth in those difficult times? Some years later he sat in his office and found a determined smile as he reflected on the question. 'It was not hard to trust youth because I love to do that', he says.

'These were the years where we had less money, and on top of that other teams invested a lot of money. It was a trophy-less period and certainly a much more difficult and sensitive period, and we needed much more commitment and strength than in the first part of my stay here. I went for a challenge that I knew would be difficult because we had to fight with clubs who lose £150 million per year when we had to make £30 million per year.'

What made Project Youth even harder was the fact the best players Wenger nurtured, like Fàbregas and Robin van Persie, were tempted away.

May 2014. FA Cup Final. Shellshock gripped Arsenal as they found themselves trailing Hull City 2-0. Wenger was assailed by anxiety. The scene he was witnessing was so hideous as to go beyond ordinary fear, or anger, or disappointment, and segue into what he calls the 'surreal'. And it almost got even worse. 'Let's not forget that at 2-0 it was close to 3-0. Kieran Gibbs made a saving header on the line. If that goes in even your own fans lose hope and you have no chance any more', Wenger recalls.

A sumptuous free kick from Santi Cazorla changed everything. It was a lifebelt in the midst of the storm. From there Arsenal recovered to win, with goals from Laurent Koscielny and Aaron Ramsey. Redemption, when it finally came, was a beautiful thing for Wenger and his players. 'It was a huge relief', he says. 'You can see how suddenly the belief is there again that we can deliver trophies.'

Indeed they repeated that FA Cup victory the following season, and won in spectacular style, beating Aston Villa 4-0. The best goal of the day came from Alexis Sanchez, a multi-million-pound coup of a signing from Barcelona. That symbolized how the age of austerity was finally over.

The FA Cup came to represent a silver lining for Wenger in his latter years at Arsenal. In a period where they couldn't challenge for the League they mastered the art of Cup football. There was more salvation to be drunk from the old trophy after a third victory in four seasons at Wembley. Chelsea were rumbled as Arsenal conjured one last brilliant team performance on a showpiece occasion for all to see.

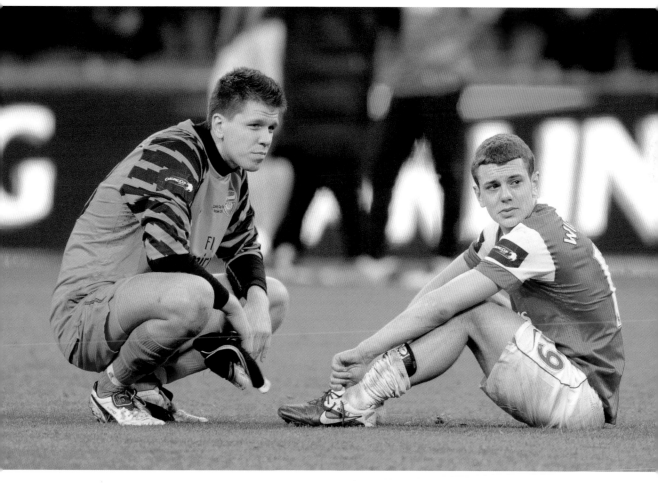

‘These were the years when we had less money. We kept facing questions about the way we wanted to play. We kept facing questions about our commitment to youth. Our basic target was to qualify for the Champions League and to pay the stadium loans back. After a while people became very impatient. We lost a League Cup Final against Birmingham, we couldn't win any trophy, which is what people want. It was a challenging period.’
Arsène

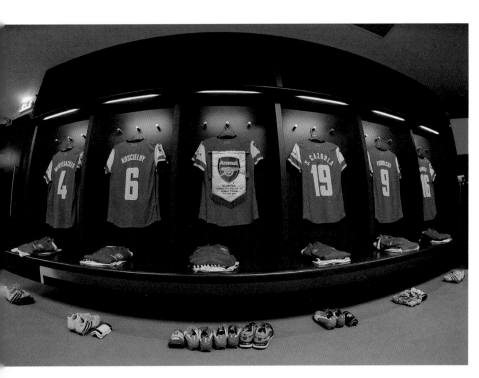

As well as being favourites to win the FA Cup against Hull in 2014, going into the game there was the added tension that critics continually added up the number of years since Arsenal's last trophy. There was so much expectancy.

'I must say I was extremely nervous against Hull. Suddenly you are 2-0 down. You had so much trouble to get there and you think, that's surreal. You get your fans to come here, you are super favourite, and on top of that you cannot deliver the FA Cup? It was absolutely unbelievable. Santi Cazorla's free kick was one of the most important individual kicks in the life of the club for years. Coming back to 2-1 you can believe again.'
Arsène

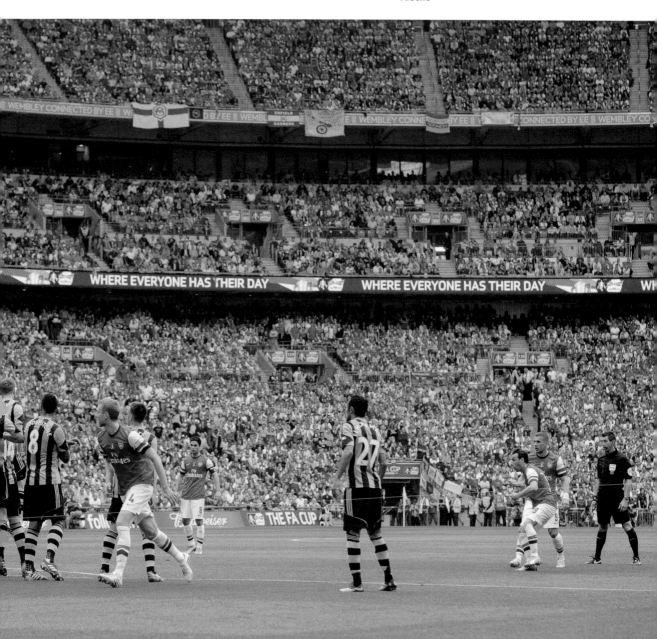

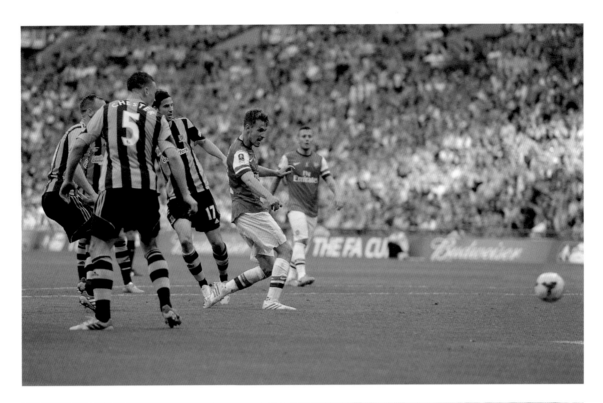

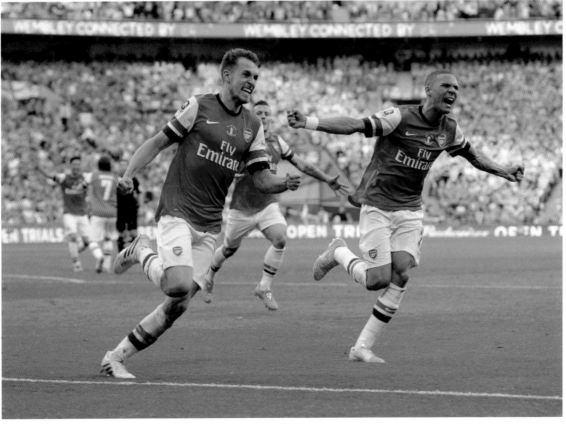

'The game was quite tough but I made the right decisions. In the end we played with two strikers, we went direct which was not our game, and in the end Aaron Ramsey scored and we could win. It was a huge relief. It was an exceptional moment.'
Arsène

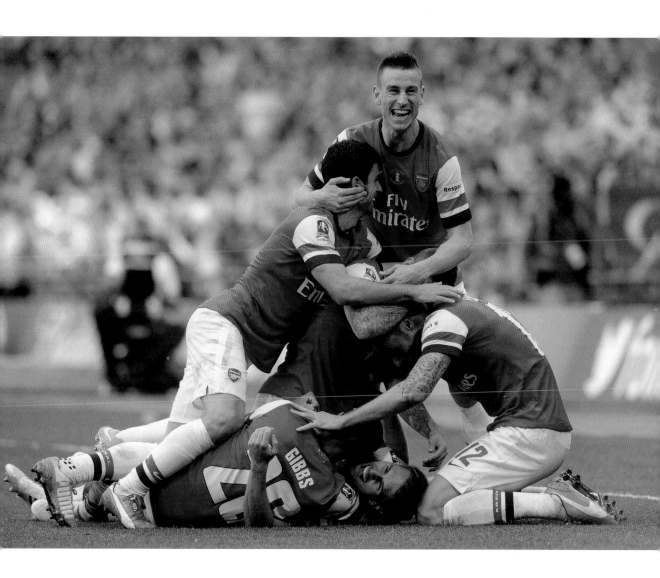

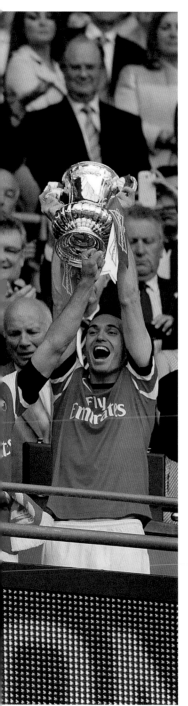

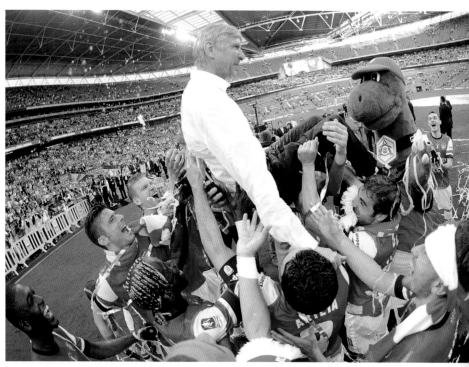

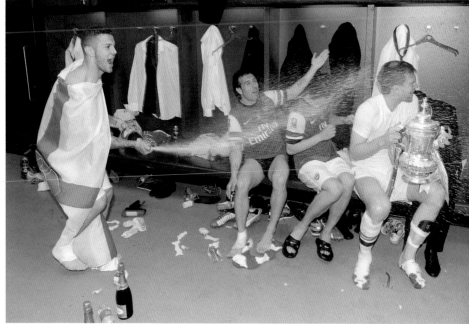

'Back at Wembley for the 2015 FA Cup final, I was anxious against Aston Villa because they played so well against Liverpool in their semi-final. I watched that game three times. What a team suddenly! I was really nervous before the final.'
Arsène

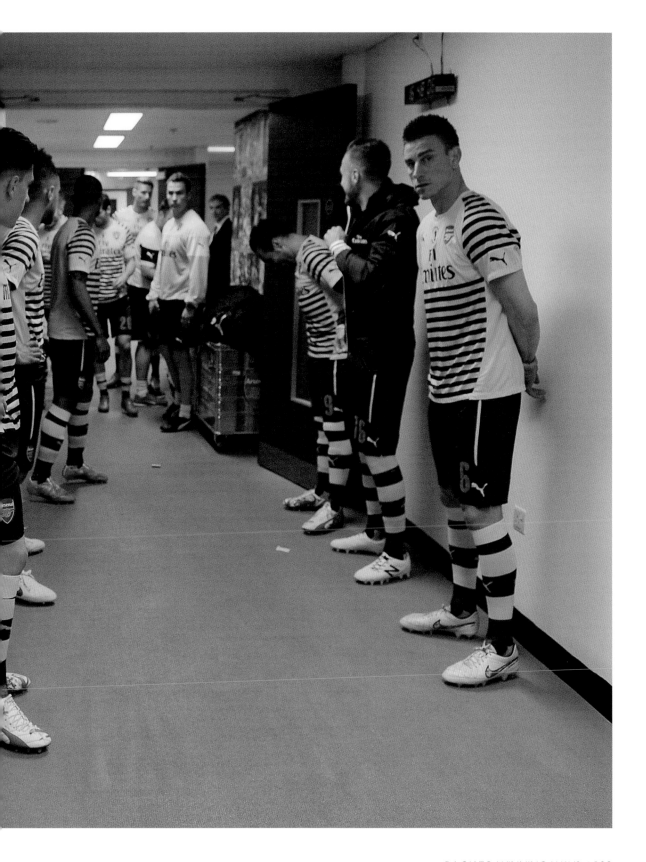

‘The great goal of Alexis Sanchez was at the heart of this game. The authority of the performance symbolizes how we had the perfect final, which you rarely get in life.’
Arsène

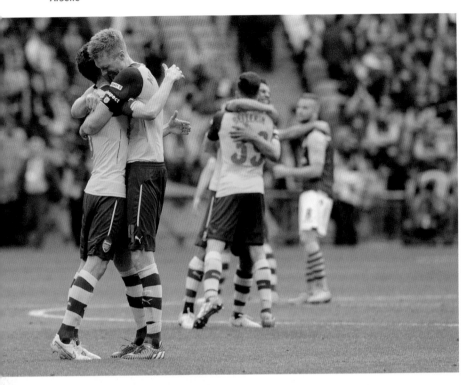

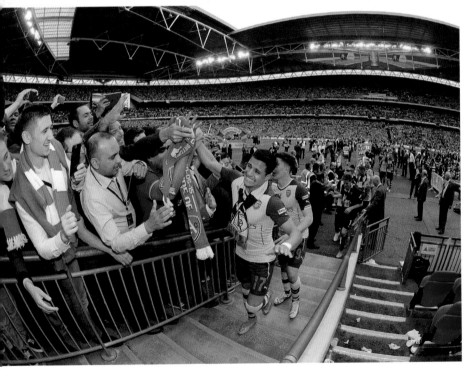

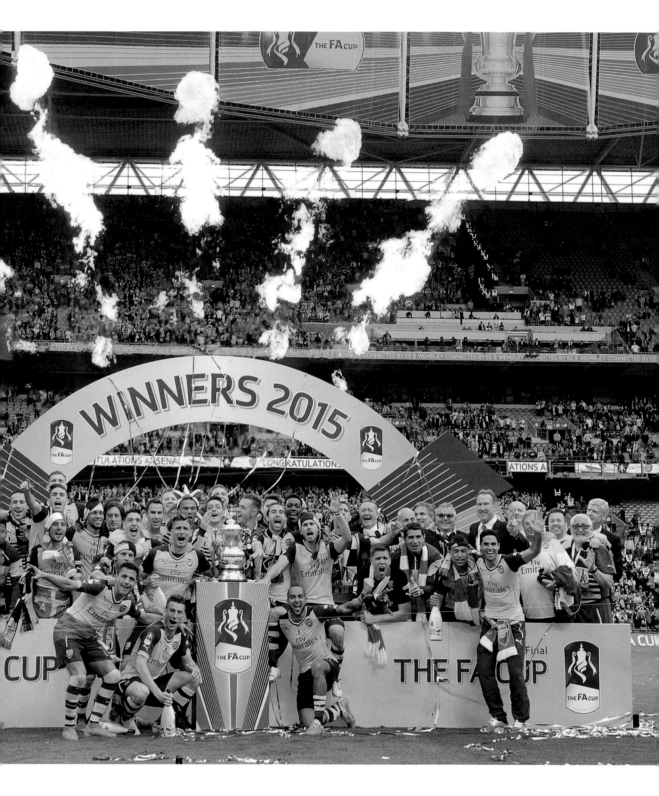

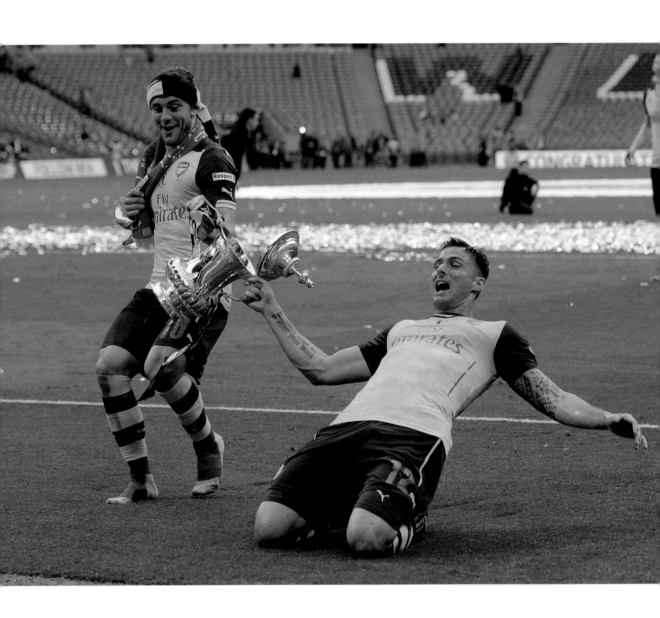

'Our third final in four years. You cannot get two tougher opponents than Man City in the semi-final and Chelsea in the final but we produced two outstanding performances. That is what made me particularly proud, because no one gave us a chance at Wembley and we responded with attitude and class.'
Arsène

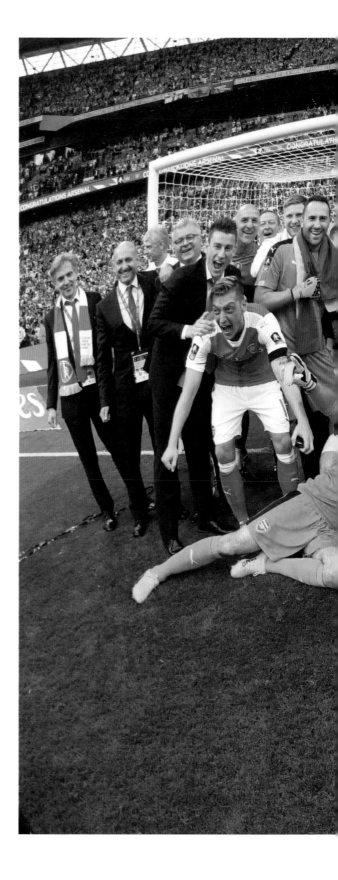

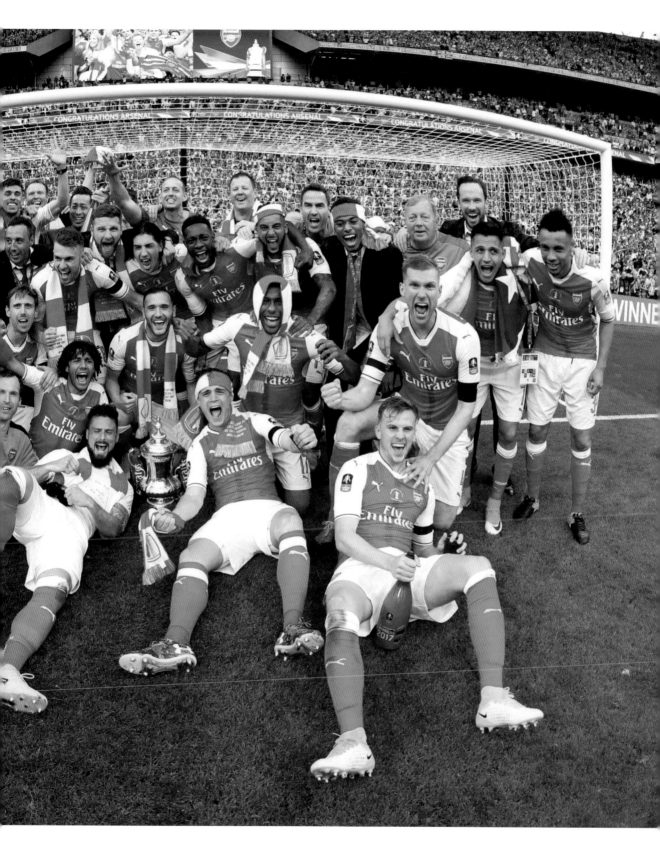

Another proud FA Cup moment for Ramsey, whose knack for a big occasion goal was also decisive in the 2017 FA Cup final.

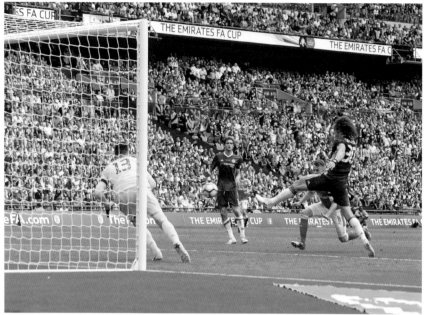

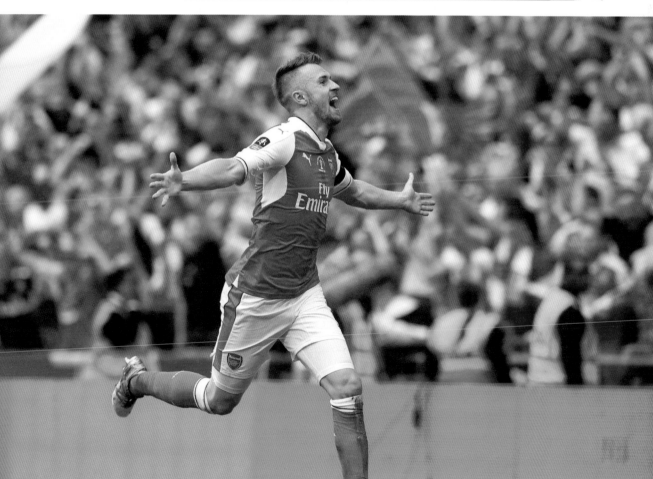

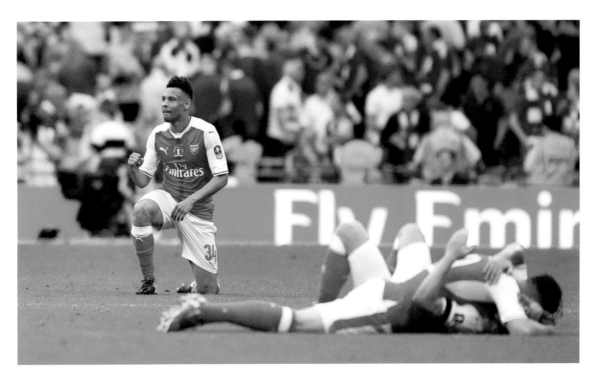

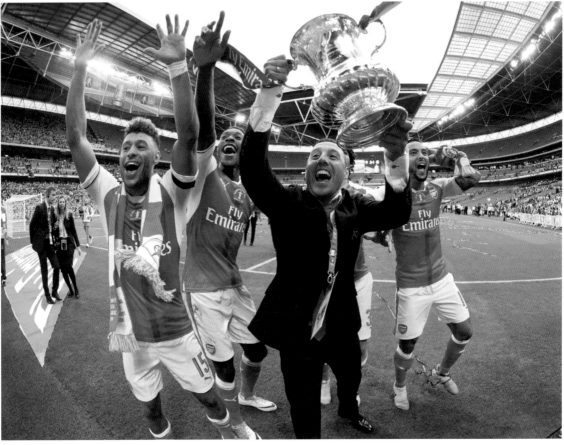

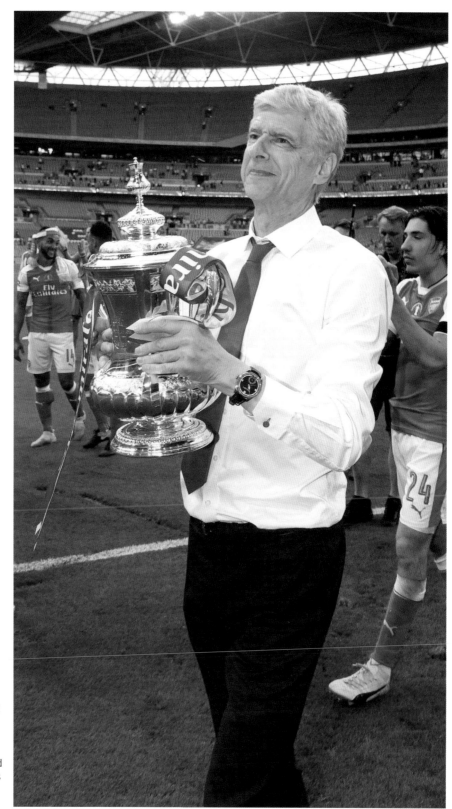

'I am very proud. You see what kind of fight you have when you want to win one. I am quite proud to have done two things that had not been done – to win the Championship without losing a game and to win seven FA Cups. It is not easy, believe me!'
Arsène

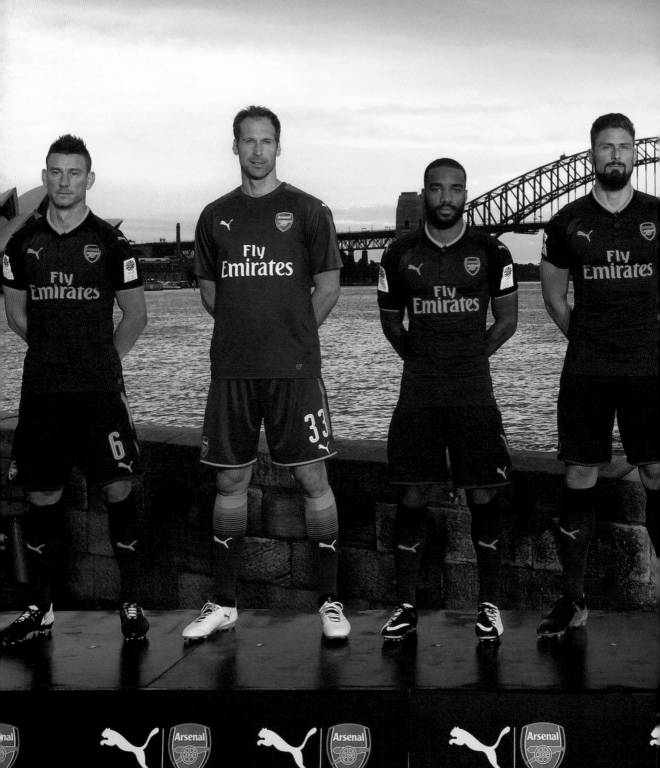

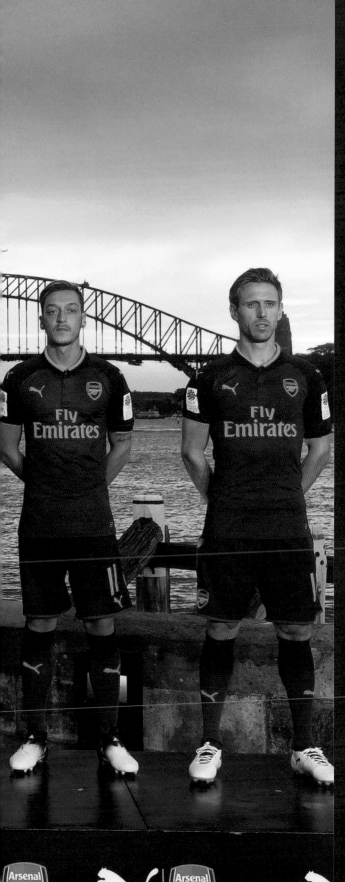

9

GLOBAL
GUNNERS

'This is the new era, this is global
Arsenal, this is the club that has a
duty towards the world fans.'
Arsène

n the hours that followed Arsenal's 2014 FA Cup win a trend sprouted up on the internet which represented the club's reach more dazzlingly than any facts and figures about how many people click on their sites and where they come from. Fans around the world began to post videos of their own celebrations and songs while watching televised scenes from Wembley. There were huge gatherings in Australia. Supporters' clubs across the USA filmed themselves singing and celebrating joyously. Fans in Asia, Africa and South America, from the Middle East to cities throughout Europe, recorded their own explosions of happiness as far-flung Gooner clans threw themselves into the moment just as passionately as those lucky enough to be at the game itself.

A little while afterwards Aaron Ramsey, scorer of the match-winner, watched a collection of these videos and found the experience quite overwhelming. It really presses home how millions of people, from all over the globe, care deeply about how the team fare. They get up at strange hours of the day or night, meet up with like-minded obsessives, wear their replica kit or memorabilia, engage on social media and devour all the information they can get on their beloved club. In their own way they are able to feel as involved as those who go to the Emirates Stadium on match day.

This is a relatively recent phenomenon in the history of Arsenal Football Club. Following the club from abroad and feeling connected was not so easy when the first trophies came for Wenger in 1998 and the means to interact via the internet were less established. A visitor from overseas who walked up Avenell Road to take a look would not back then find an accessible club tour or a megastore. Fortunate ones might come across Paddy Galligan, who often stood guard outside the Marble Halls and was known to invite passers by inside to have a look at the pitch and the dugouts.

The club Wenger joined in the mid-1990s, although broadening its horizons quickly, was still quite a homely place. International fame was more low key than today. One of the things that continually impresses Wenger is how when he is travelling he meets overseas fans who have such detailed knowledge of the club.

Figures calculated 20 years into his era showed Arsenal have over 1 million fans outside the UK who are digital members. From the total of well over 7 million twitter followers, 80 per cent come from abroad. For another striking example of how strong the international fanbase is, consider that Arsenal have twice as many Facebook fans in Cairo than London. The club produces content for television channels that broadcast special Arsenal programmes in 130 different countries. There is everything from a Chinese version of the official website, via an Arabic Facebook page, to a supporters' club in Mauritius.

Like a whirlwind the globalization of football has made its mark on Arsenal who now feel influences from abroad from top to bottom. 'We have an American owner', Wenger says. 'You take the owners of English football clubs in 1996 and compare that to the owners today and you will see how much football has changed. The owners, the attendances, the fans, the way to prepare, all that has changed.'

Perhaps the last bastion to fall with all these sweeping changes was the pre-season tour. Arsenal were one of the last of the Premier League's status symbol clubs to give in to the temptations of a money-spinning, goodwill-spreading, global-reaching escapade. For as long as possible Wenger resisted, preferring a more serene, low-profile preparation. He liked to ramp things up quietly in the calm of the Alps, where the closest they came to a big sponsor's event was a local man dressed in a Ronald McDonald costume taking a kick off with a mildly bemused Dennis Bergkamp. Modest surroundings, minimal distractions, no long haul flights and interrupted body clocks was what pre-season was all about for Wenger.

But Arsenal have started to embrace the notion of taking their brand to their long distance fans. Since their first trip in 2011 they have visited China, Malaysia, Singapore, Japan, Indonesia, Vietnam, the United States and Australia. Wenger recognizes how the internet has had a transformative effect on the fanbase. It is now the duty of a club, not just financially but also on an emotional level, to touch base with people around the world. Something about taking his team to meet those who care about it strikes a chord about the 'values' Wenger cherishes. That Arsenal passport he says he has now was very well used.

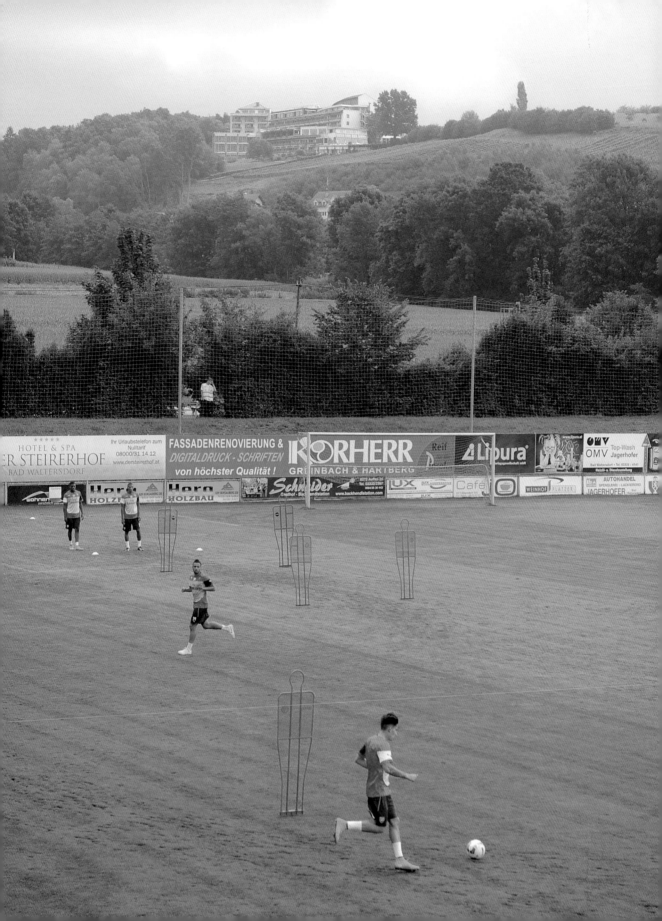

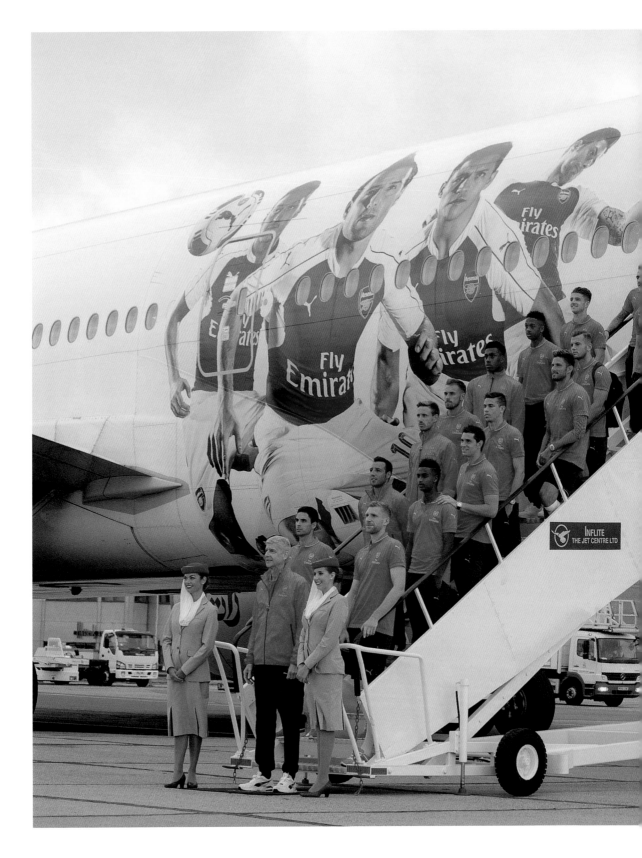

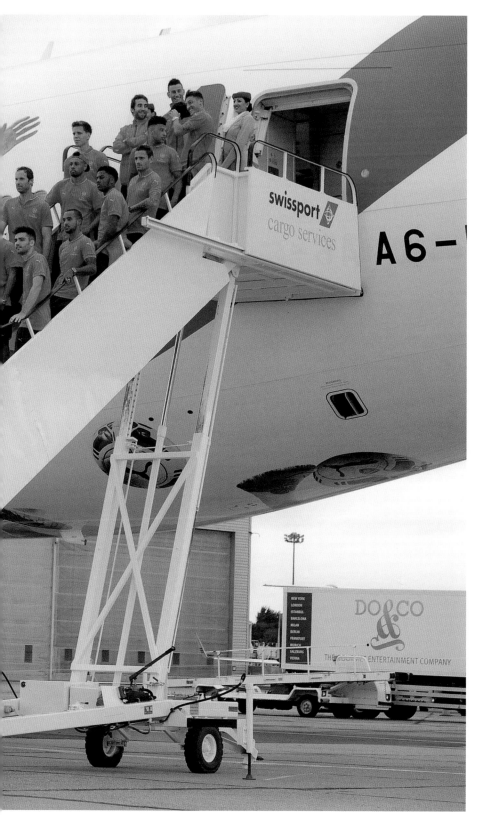

The contrast shows how profoundly pre-season has changed. From a health spa in Austria to Arsenal's branded plane flying to Asia.

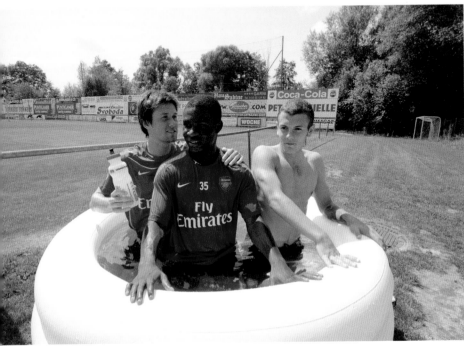

'That was the period I miss the most, not because we had great success, but because you could prepare the teams properly and serenely. Today every preparation is a compromise between commercial interests and sport.'
Arsène

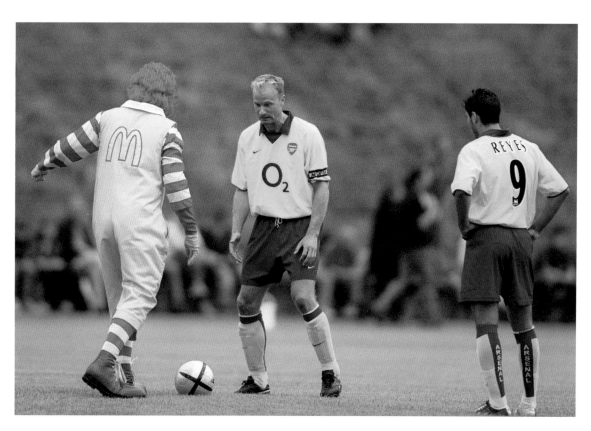

*Dennis Bergkamp looks thrilled to kick off
the game with Ronald McDonald.*

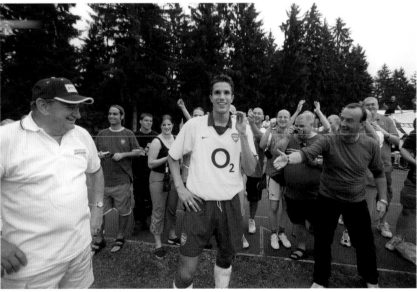

*Stuart remembers the old-
style pre-seasons fondly.
'What I loved was that it was
like Sunday morning football,
the grounds were open and
fans could get close to the
players.'*

Lunchtime or killing some time with computer games, it used to be nothing too fancy.

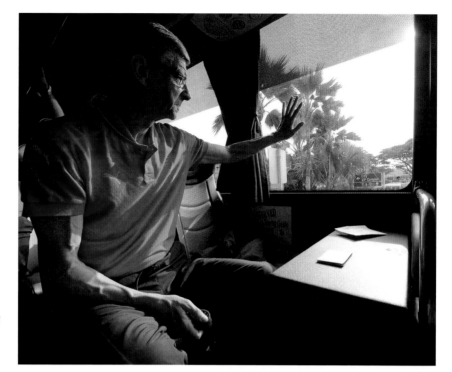

Going to Asia, the interest ramped up massively. This view from the team coach is what greeted the travelling party on day one of the tour. To see so many Arsenal fans on the other side of the world brought home how much people who live far from London care about the club.

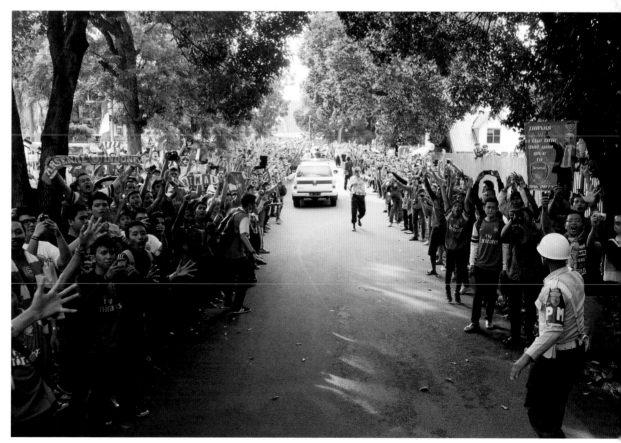

'It all started on the internet. Your sponsors became global, your fans became global, and of course they want to see the team. These days travelling is needed to strengthen that connection.'
Arsène

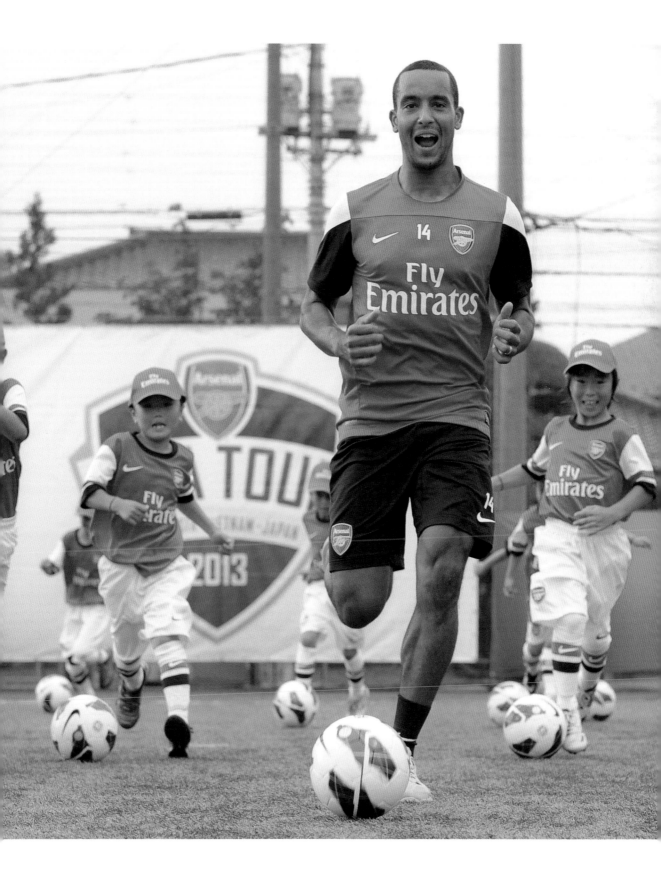

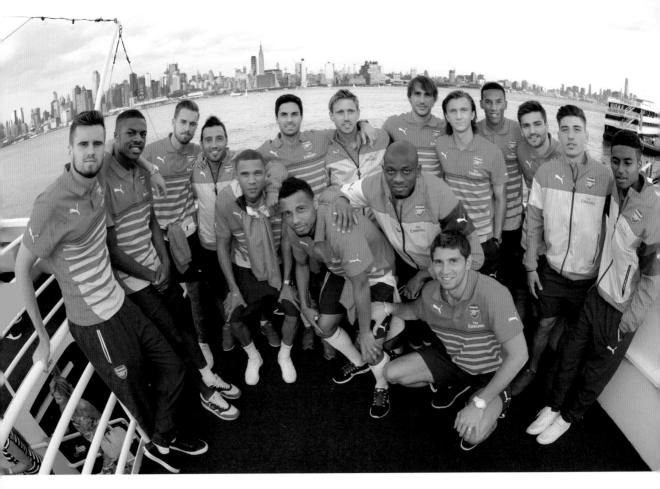

On a boat trip with the New York skyline in the background.

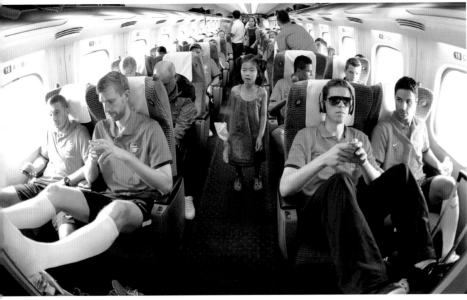

Travelling on public transport. Here is the team on the Japanese bullet train.

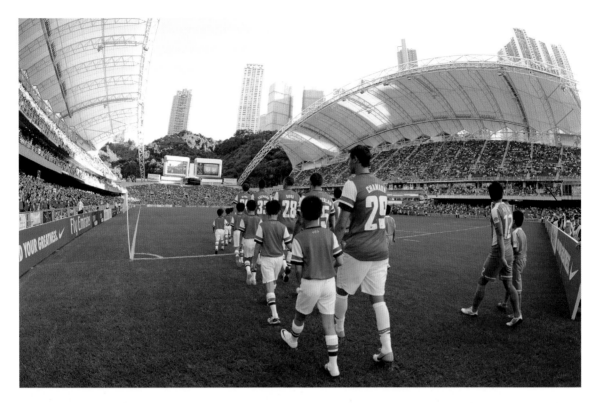

This is outside our hotel in Kuala Lumpur. This lady was so desperate to meet Theo Walcott she was crying. He went to autograph her stuff, and with her husband they followed the team bus all the way to the airport with a sign that said 'We love Arsenal, please come back and thank you for coming.'

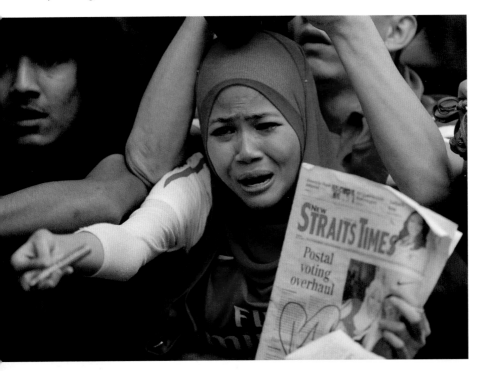

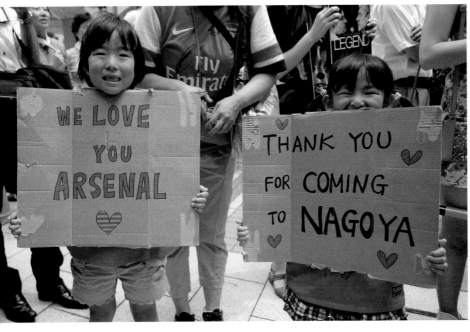

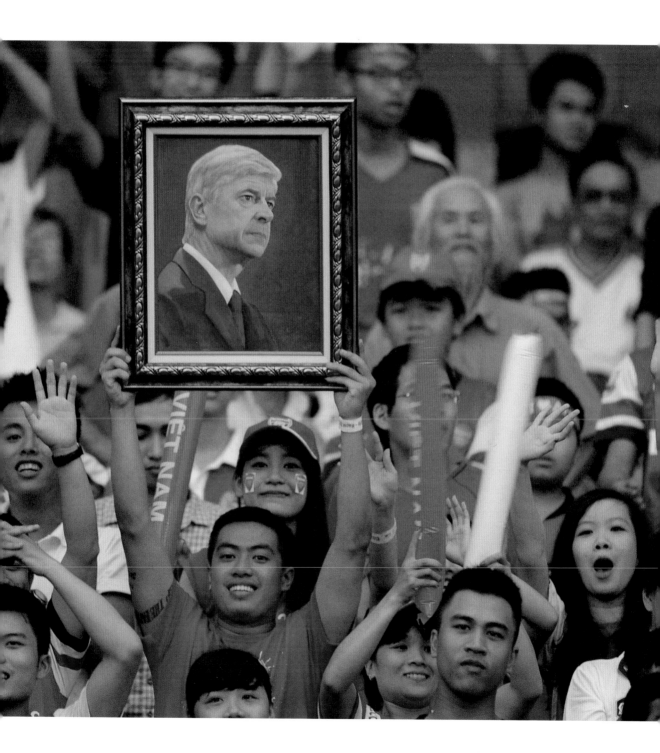

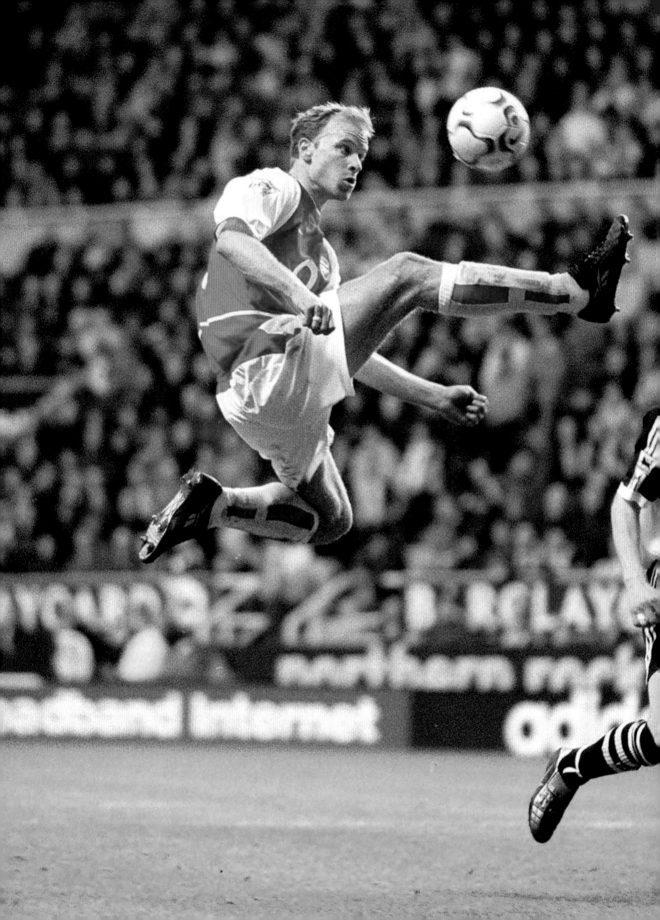

10

THE GAME
WE LOVE

'Mr Perfection. An exceptional brain. You
ask any player of Arsenal Football Club
who is your top player? They always say
Dennis Bergkamp.'
Arsène

The moment Arsenal supporters first got an inkling that Arsène Wenger would introduce a change of style came just before he was even officially unveiled at Highbury. In a home game against Sheffield Wednesday at the start of the 1996–97 season, under temporary management, workmanlike Arsenal were trailing 1-0 when an injury led to the introduction of a tall kid from France who Wenger had told the club to buy before he had formally left Japan for England. Patrick Vieira ambled into midfield and a new spell was cast.

Rewinding pre-Wenger for some context, in the latter days of the George Graham era midfield had become some sort of wasteland. Arsenal were functional in that department, and long balls often passed it by altogether in a bid to hoik the ball up to the centre-forwards quickly. Under Graham's replacement Bruce Rioch there was no radical improvement.

Enter Vieira in September 1996. His mix of commanding determination and physicality with brilliant high-precision passing left onlookers watching him for the first time stunned.

Of course, Dennis Bergkamp's arrival in 1995 had already began to add remarkable embellishment to Arsenal, but what the presence of a Vieira brought was a sense that the entire game-plan, not just the refinement of individuals, would be viewed with a fresh perspective. Bergkamp soon felt able to draw the comparison with the 'total football' principles he had been educated with in Holland.

A more aesthetic method of playing clicked remarkably quickly when Wenger arrived. For the manager, observing as his team found its new personality was a fascinating period. 'The trend moved from a more direct game to more of a continental game', he suggests. 'The proof of that was in the success of players of the calibre of Bergkamp, Overmars, Vieira. But it also changed the style of play for the English players. When I arrived I thought our defenders were good defenders, but I discovered they were also good football players. I had a preconceived idea of them as just kickers of the ball. I realized after two or three weeks that wasn't true. That is when I became optimistic. When I encouraged them to play, they wanted to express themselves. That was interesting.'

The pattern emerged for perfectionist football – the alliance of dedicated work and self-expression. The new Arsenal was set in this mould. Wenger often uses the phrase 'the game we love'. It is hard to disagree with this ideal in principle, especially as that game can be crystalized by, say, Bergkamp executing a pass nobody else imagined for Henry to sear onto, only to choose to play an inch-perfect pass to Pires to finish with aplomb.

In difficult moments critics have railed against Wenger's commitment to the game he loves, suggesting a kind of naivety to stick to the mission of playing a certain style irrespective of the opposition. Even so, the manager is proud of redefining what Arsenal means, and the aspiration to play attractive football as much as possible.

Of course the crux of it all is that the beauty of Arsenal's best football during the Wenger years was always in the blend – the subtlety and the substance. The dash with the determination. The finery and the feistiness. All the greatest exponents of football conducted by Wenger possess an abundance of both. When the Arsenal supporters chant in honour of '49 undefeated', it is a reference not only to the achievement of English football's longest unbeaten run, but also to the style that time evokes.

The great players associated with it arrived at the club in a variety of ways. Some, like the old English core, were already in-house and open to the different way of playing that was asked of them. Others, like the French connection, grew up attuned to Wenger's ideals and he was perfectly placed to recruit them because of his contacts in his homeland. Throughout his career he has been a keen promoter of youth, never afraid to play teenaged talent if he believed in them. There are the golden touch signings, when Wenger's eye for a diamond came off more often than not.

The Arsenal of today still reflects the ideas central to the Wenger methodology. He is proud of the young players who emerged in recent years like Hector Bellerin and Francis Coquelin. He has always backed his eye to recruit talent of the refinement of Santi Cazorla, or those he saw as potential that could be nurtured such as Laurent Koscielny. He has enjoyed working with the established class of Alexis Sanchez and Petr Cech.

Regardless of critics or trends or money, his fundamental belief in 'the football we love' will never change.

‘These guys were great football players but above all great fighters. These guys were ready to die to win. Martin Keown, David Seaman, Nigel Winterburn, Tony Adams, Steve Bould, fantastic guys. Ray Parlour and Ian Wright were exactly the same. Lee Dixon couldn't walk any more, but on Saturday when the game started he would never disappoint you. They made my job basically. This is the generation who was easy going during the week. But they were absolutely ready to kill the opponents come match day. This was the period when you didn't hug or kiss each other when you were walking out on the pitch. It was: come on my guys, this is a fight.’
Arsène

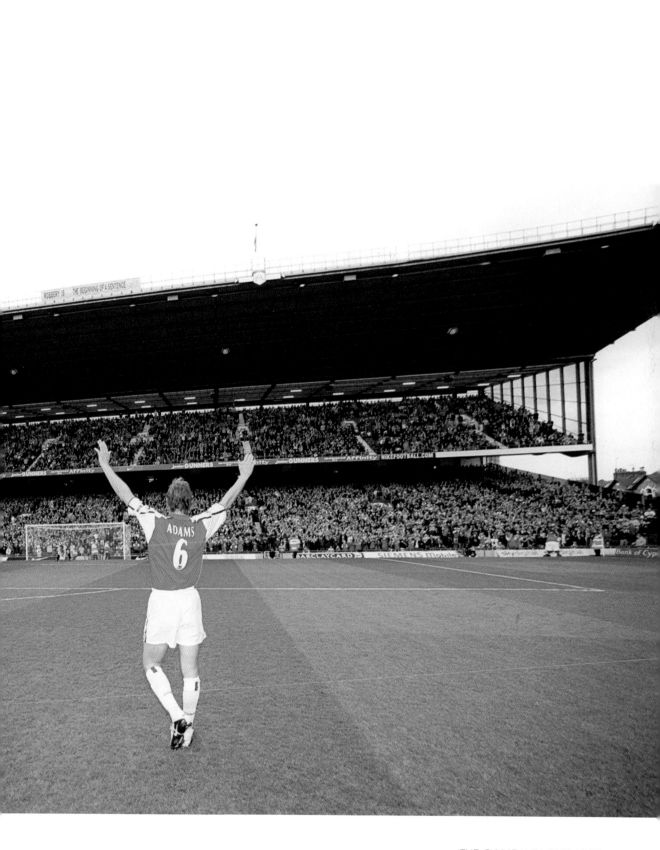

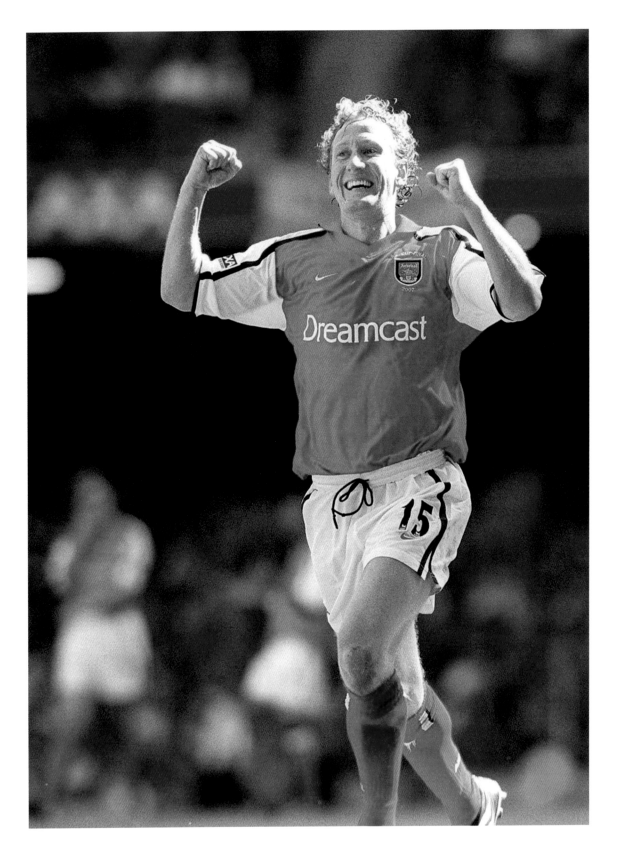

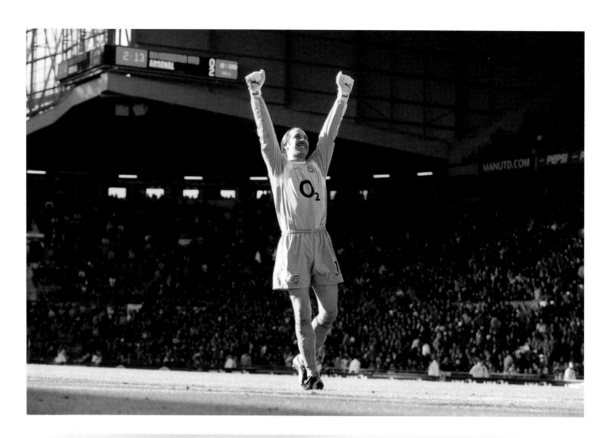

‘These were all exceptional football players. Robert Pires was top class. Emmanuel Petit for me was a vastly under-rated player, a massive player. Patrick Vieira is one of the legends.’
Arsène

'Thierry Henry of course is a history of the club in himself. Nicolas Anelka was the first credit I got for bringing in a striker. These are the players who certainly made my career here. They represent my influence on this club. I was lucky.'
Arsène

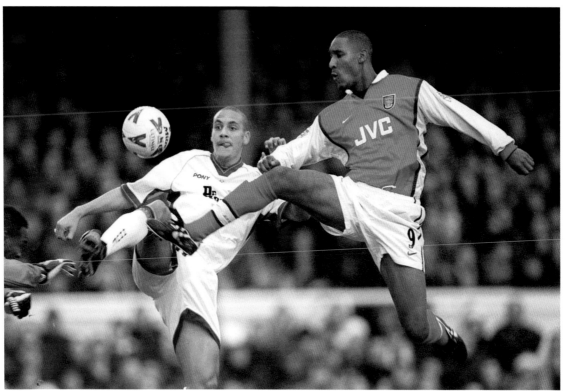

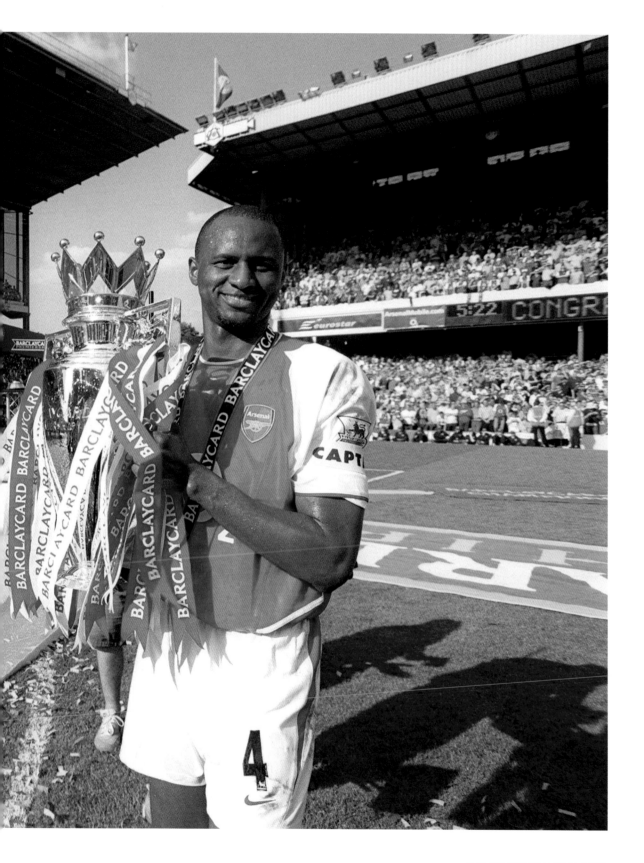

‘You always hope a transfer will work out and these players were outstanding for Arsenal. Speedy Marc Overmars was special. I saw Freddie Ljungberg giving a hell of a lot of problems to Martin Keown while watching him on television as he played for Sweden against England. I decided to buy him then. He became a huge Arsenal player.’
Arsène

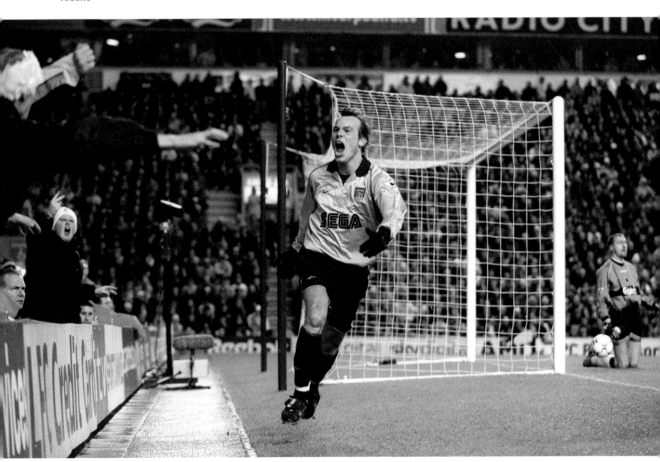

‘Lauren was recommended as a right midfielder and I transformed him into a right back – I had many problems to convince him he could play there. Kolo Toure was turned down by four or five clubs in France. He came here just before he flew back to the Ivory Coast on trial and I told him: you will stay with us, my friend.’
Arsène

'Gilberto is a classy person. I bought him after watching him at the World Cup in Japan in 2002. He is a guy who is less spectacular than many others but a person of class. Sol Campbell's transfer is in itself worth a book. I knew after having done the transfer with him that I could rely on this guy.'
Arsène

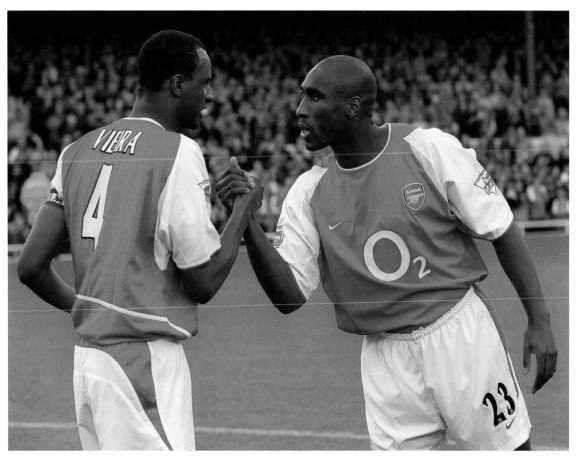

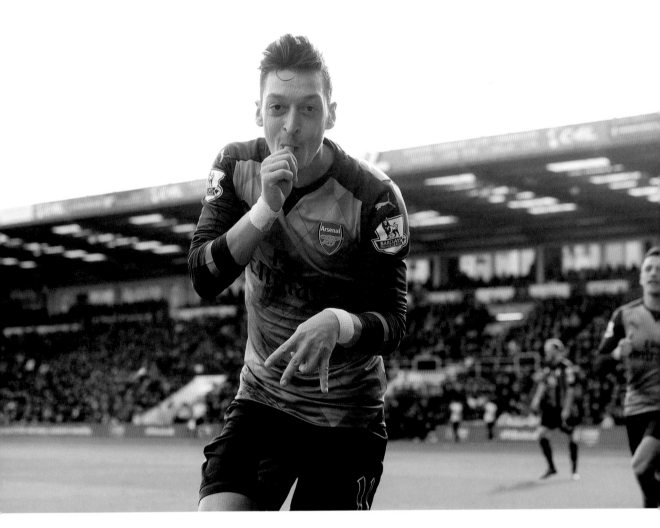

'This group typifies how Arsenal has grown up again financially. Buying Mesut Ozil and Alexis Sanchez – that was not allowed for us seven or eight years ago. They show we are back on track. If we find a player we can buy him. And if we spend the money we spend it in the right way, as these are two exceptional players. Santi Cazorla was down to our eye and the way we want to play football.'
Arsène

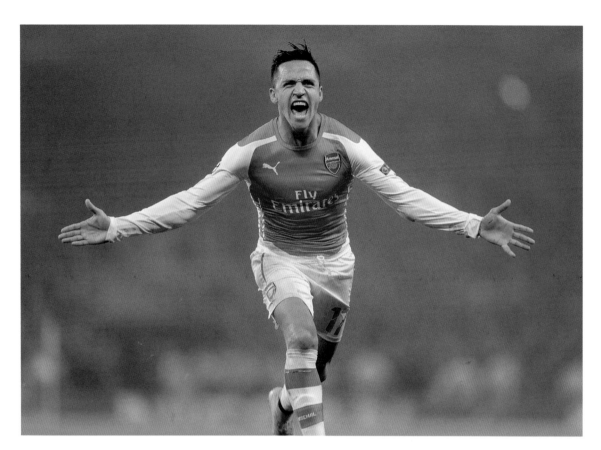

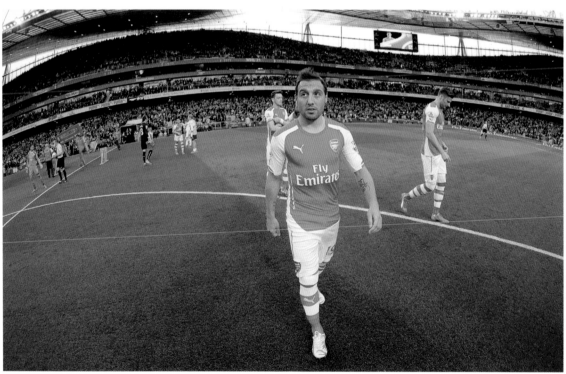

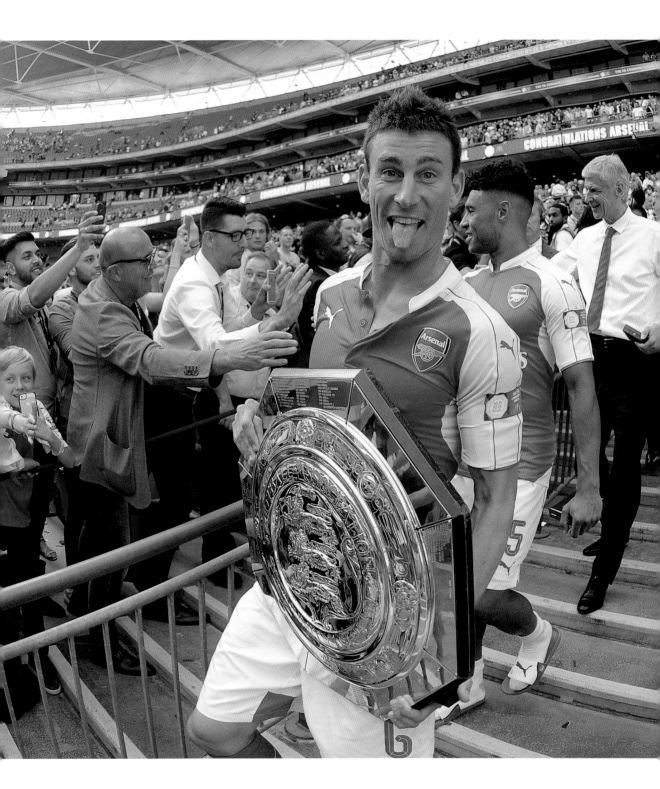

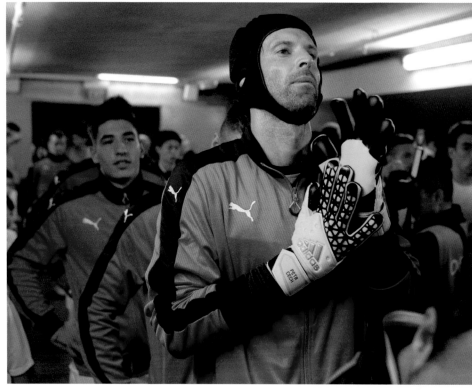

'Laurent Koscielny is a player I saw that I liked in France and he has become a huge player here. I met Petr Cech before signing him and we had a long discussion. I was deeply impressed by his knowledge, his professionalism, the details he considers. I got the whole package.'
Arsène

'I love to give chances to young players. From the moment Ashley Cole played his first game he never went out of the team. Unfortunately he left the club but I still think he was a huge player. He is one of the few players who made a massive career after leaving us.'
Arsène

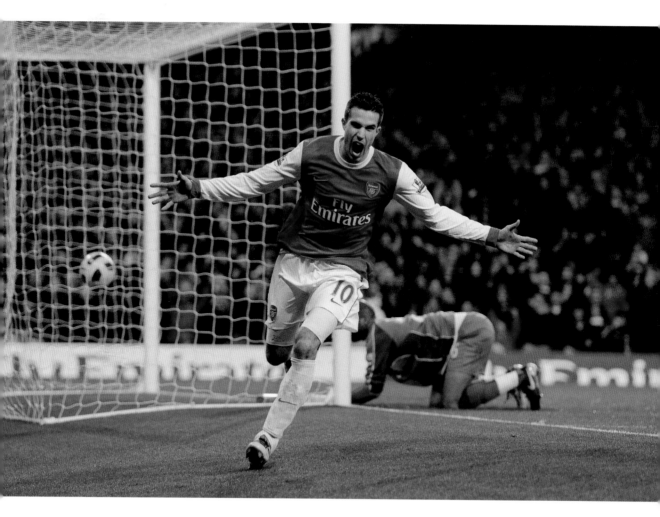

‘I am very proud of Robin van Persie's success because it was not always obvious. He was a bit of an outsider at Feyenoord. I was very patient with him and for me he became one of the best players in the world as a striker.’
Arsène

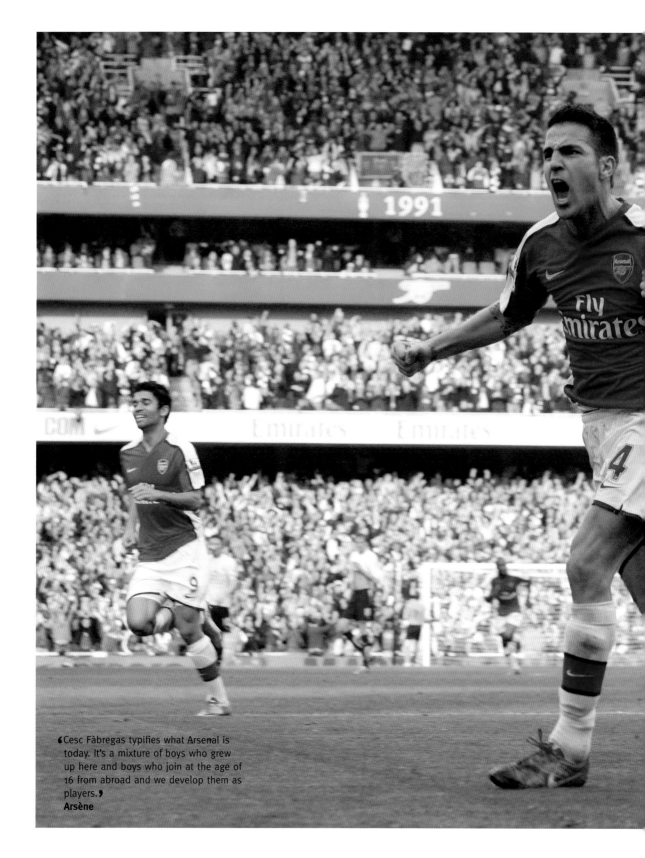

'Cesc Fàbregas typifies what Arsenal is today. It's a mixture of boys who grew up here and boys who join at the age of 16 from abroad and we develop them as players.'
Arsène

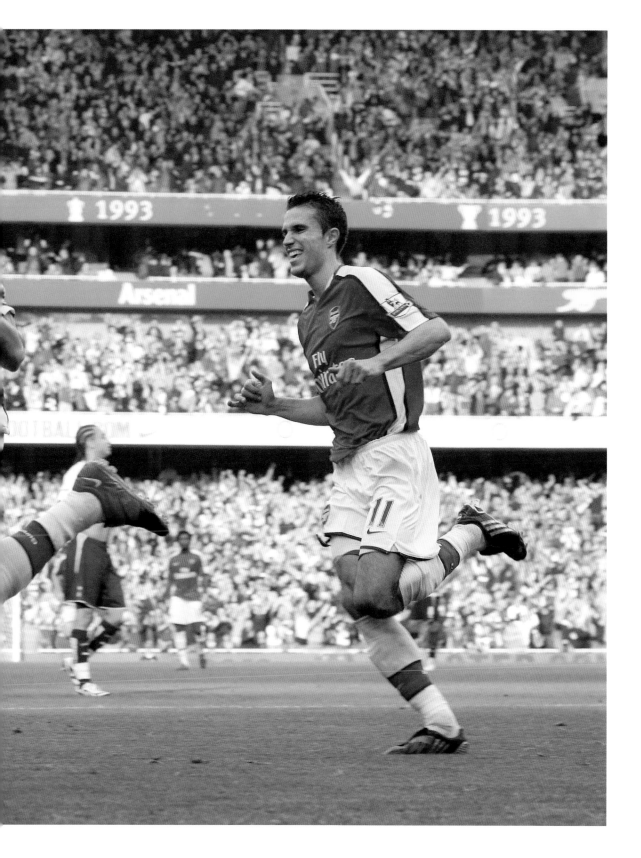

‘Jack Wilshere is Arsenal. Jack and Ashley
Cole and Kieran Gibbs were the ones who
were here as kids and moved through all
the ranks to become massive players. It was
no surprise to see Aaron Ramsey have the
engine and technique to arrive to score such
an important goal for Arsenal as the one
to win the 2014 FA Cup. That was a turning
point for the club.’
Arsène

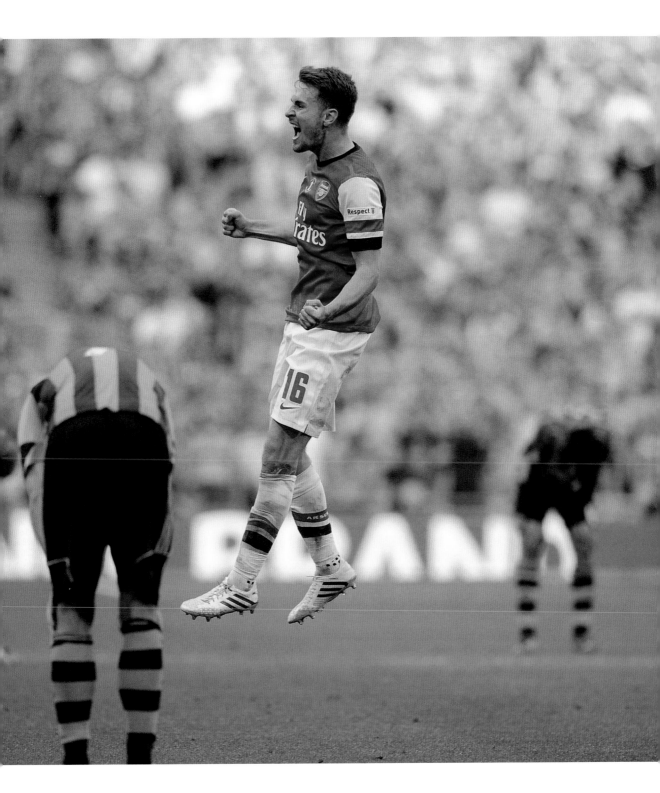

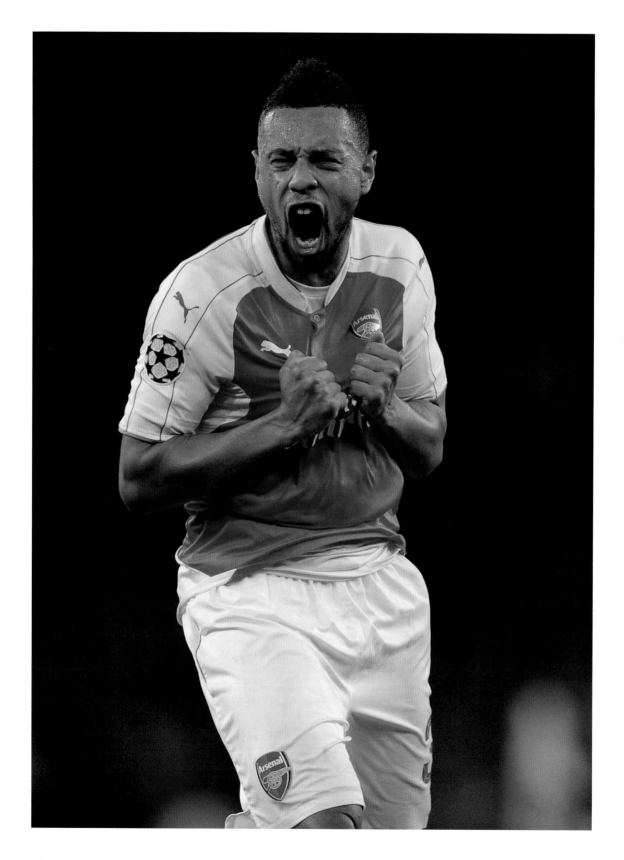

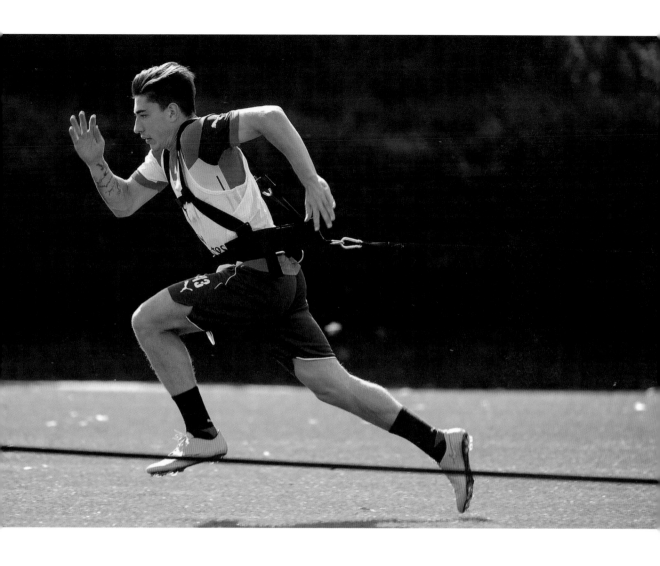

'Coquelin is a lesson of humility and patience. Humility because if you asked me a couple of years ago "will he make it here?" I would have said "certainly not". I don't like to say it but in Germany when he was on loan he was voted as one of the worst transfers of the year when he was there. Today he is an exceptional football player. I want to give credit to him for never having given up, for believing in himself, and for accepting all the challenges I set for him. Even "go and show me you can play at Charlton and I will take you back". He deserves huge credit. Hector did not have the best start. His defending was very questionable. He went to Watford on loan, didn't play much, came back here and has become a very important player for this club. I like this photo because even a belt cannot hold him back. He is Speedy Hector.'
Arsène

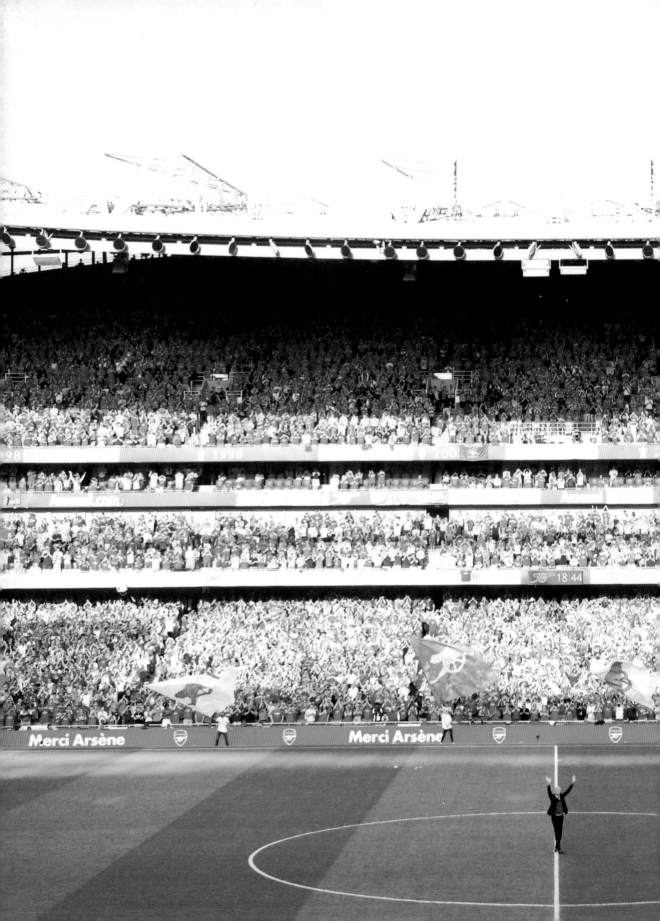

11

MERCI
ARSÈNE

'What I will miss is the competition itself. The collective feeling, the sharing of emotions with people you work with on a daily basis, the desire to feel something together and the target you always have in front of you. I will miss the intensity of it all, because that is all I have known in my life. What I will miss least is certainly the huge disappointments and huge suffering you can get. The loneliness you can experience when things don't go well. In this job you get too much praise when things go well and too much negativity when things don't go well. You are always in an excessive world. So that's why it is important to be balanced, to have your feet on the ground and take a little distance. I have friends who can go and lay on a beach all day long for the whole of their holidays and I envy them. I just can't do that. I get bored. I need to be doing something. I need a challenge. I have lived and breathed football all these years and it's a passion – I can't imagine doing anything else.'
Arsène

The shockwaves pulsed, suddenly and powerfully, from Highbury far and wide in every direction. Arsenal without Arsène? Although people had pondered and debated it for years, confirmation was flabbergasting. It came seemingly out of nowhere on a quiet Friday morning in April 2018. The statement that flashed up on the club website, announcing that Wenger felt it was 'the right time' to step down at the end of the 2017-18 season, was factual but also packed an emotional punch. 'To all Arsenal lovers', Wenger signed off, 'Take care of the values of the club. My love and support forever.'

It was a where-were-you-when-you-heard-the-news sort of moment. Most of the surprise was not borne out of the actuality, because after 22 years at one club with the team on the decline, the idea that a man in his late sixties might not be Arsenal manager forever was a well-worn subject. The shock was in the timing. Wenger's principles meant he was proud of the fact he had never reneged on a contract. So to call time on this one early, and to announce it before the end of the season rather than in a quieter zone of the summer, felt strangely out of character.

The huge benefit of this unexpected announcement was that it allowed everybody time to express their gratitude and offer their farewells. It encouraged Wenger and the Arsenal fanbase to embrace, to reconnect with maximum respect, and to remember why they had thought the world of one another in the first place. That had been a problem during the tensest periods. When the most critical supporter unrest was aired in public the manager was dismayed that the club's good name was being devalued. But with the break-up announced, all bad feeling melted away and the compulsion to acclaim the best of times, to recognize all the high notes Wenger brought to Arsenal, was heartfelt and cathartic.

'It was a strange period', Wenger reflects. 'Switching from contestation to unanimity in just a few days. Surprising, but quite nice also. I have the impression people wanted to salute my longevity, my fidelity to my club and perhaps the ideas about football I always tried to defend. I take it as a sign of recognition for the total commitment I have always had towards values I hold dearly – the desire to play dynamic, attacking football with a certain idea of

how to go about it, too. My type of loyalty probably doesn't exist any more. Maybe the dinosaur I became was the last symbol of times that have changed.'

The final home game evoked a glorious sunset. The red inside the Emirates was a richer shade than usual, everyone wearing their 'Merci Arsène' T-shirts. The team gave an exhibition of classic Wengerball. A couple of members of Arsenal aristocracy, his old coaching friends Pat Rice and Bob Wilson, presented him with the gold Invincible trophy in honour of his most beloved achievement. The crowd sang to honour the man as well as the manager. He duly thanked them and gave a speech about what Arsenal meant to him: 'It is caring about the beautiful game, the values we cherish and something that goes through every cell of our body.' The emotion of the curtain call ran deep.

Wenger's farewell tour took on an unexpected dimension as it soon became clear that it was English football in a broader sense, beyond London N5, that wished to say thank you and good luck to a manager who became such a figurehead, such an influence, for the game across the country. He was saluted by the Burnley fans who attended the party at his last home game, the Leicester supporters who sang his name at the KingPower, he received a present from Sir Alex Ferguson in front of an unusually benevolent crowd at Old Trafford, and a guard of honour at Huddersfield, where the Yorkshire crowd rose to offer a standing ovation on the 22nd minute in honour of all his years at Arsenal. The goodwill came in giant, well-meaning waves, prompting Wenger to quip, 'I should have announced every week I retire.'

The legacy is enshrined in Arsenal folklore and it was meaningful that everyone was able to celebrate it while he was in situ. The number 22 became symbolic. Managers don't have shirt numbers, but it was important to recognize this remarkable longevity. 'I have met fans and people for whom I am the only Arsenal manager they have ever known,' he says. Few people under the age of 30 at the time could have properly remembered anyone else. 'It's the end of a long story for me, the end of my contribution to Arsenal. I will always feel grateful for having led this club that I cherish so much for such a long time.'

With a final, theatrical bow for the Arsenal fans at his last ever match, some 1,235 games and a myriad emotions after the first, the curtain fell.

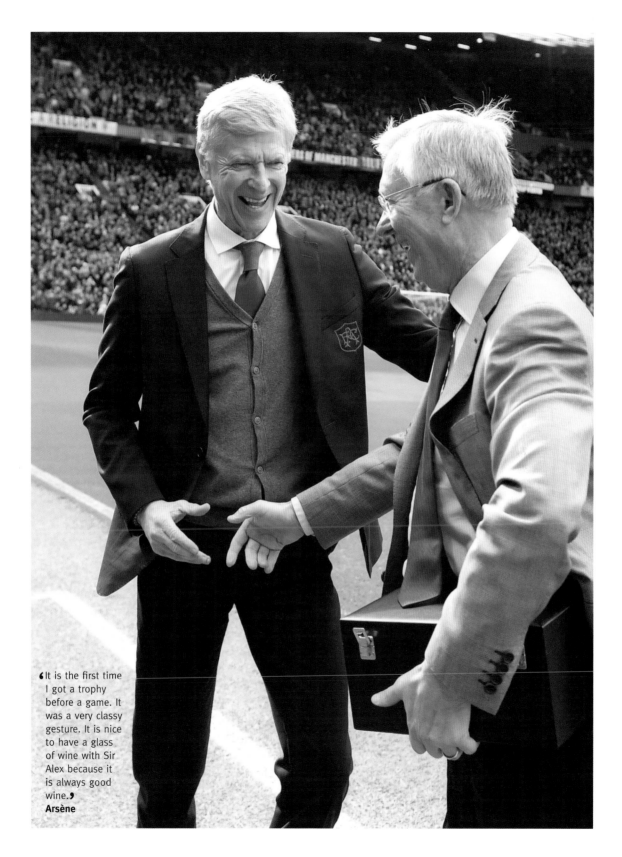

'It is the first time I got a trophy before a game. It was a very classy gesture. It is nice to have a glass of wine with Sir Alex because it is always good wine.'
Arsène

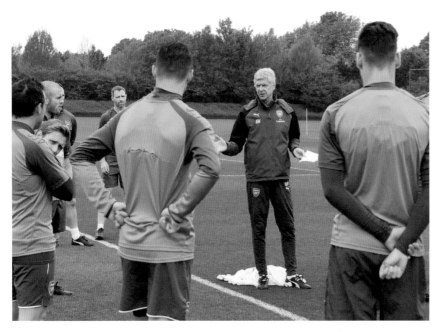

One last training session at London Colney

'After all these years the car could drive by itself. It goes on the M25 and turns off at Colney.'
Arsène

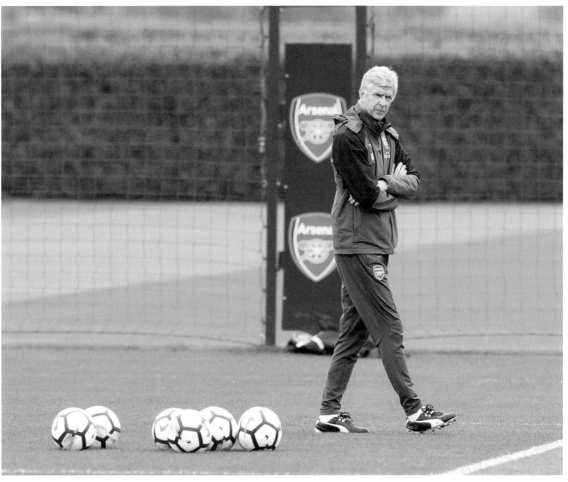

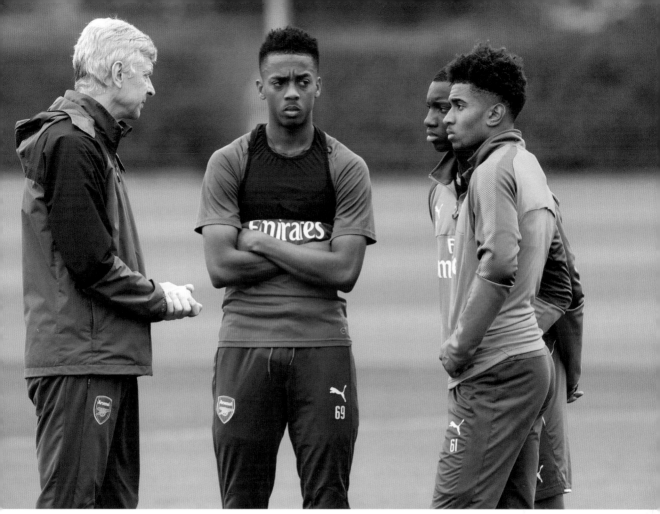

'I look around and see that life goes on. There will be youngsters training and playing and that's a reminder of the passion I have for this game and my role as an educator. When you're a young boy you have a dream and to fulfil that dream you need attitude and talent but you also need someone to give you a chance.'
Arsène

Visiting the Emirates the evening before his final home game, the boss was able to make some final inspections, including the Merci Arsène tribute T-shirts, and take a quiet moment to himself to look around the stadium.

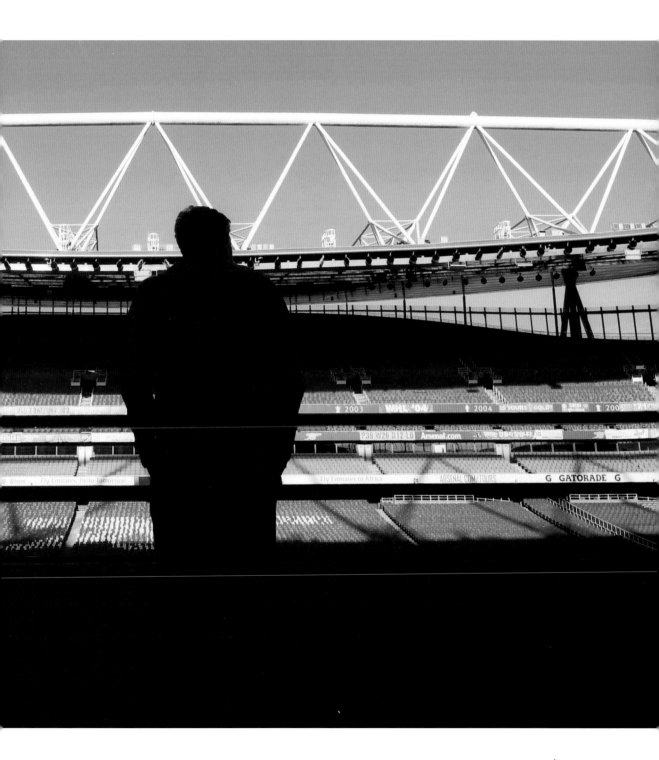

'It was absolutely magic. I will never forget a day like that. I tried not to get too emotional – it would be far too much! We had fantastic weather. We played the game we wanted to play. Everything went well. I am a fan – the fan inside suffers when it doesn't go well and I am happy when it goes well. That will continue. You don't stop the love story from one day to the next. That will never end.'
Arsène

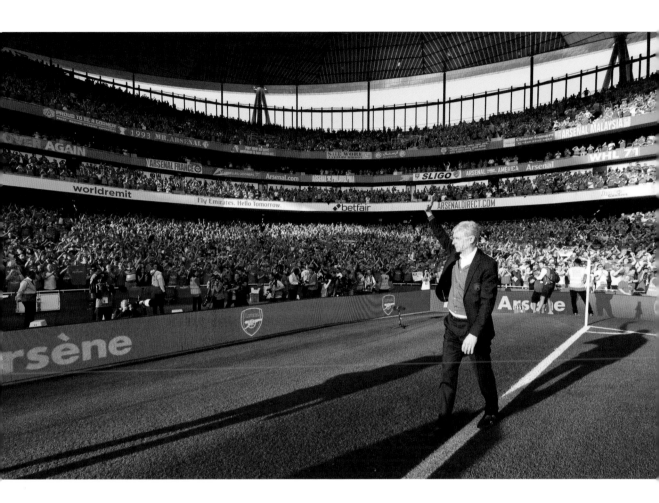

‘It was a privilege to work with so many great people – because first of all they were great people and after that great players.’
Arsène

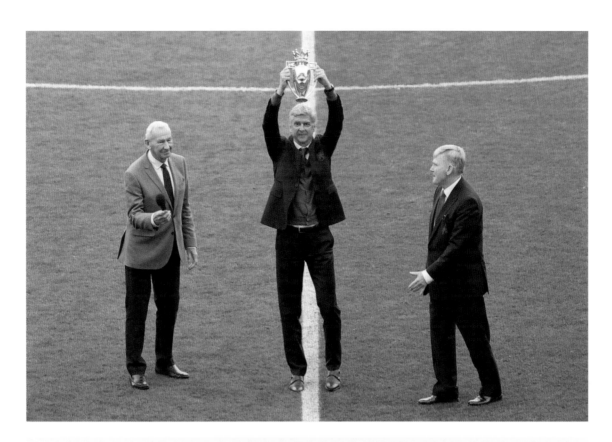

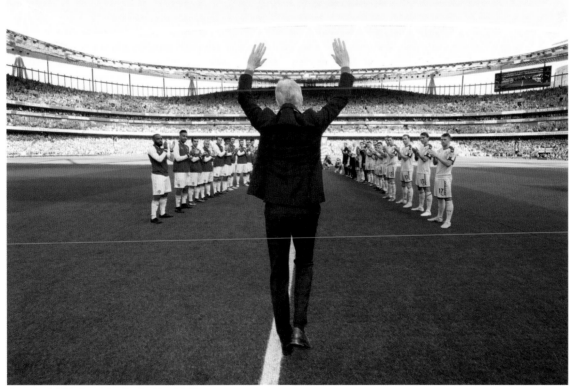

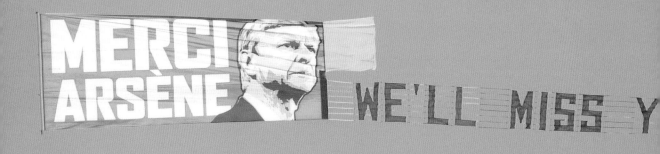

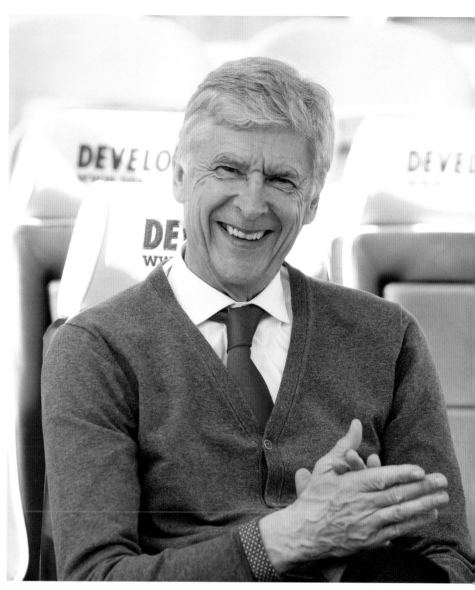

'It was such an emotional day. After 1,235 games to realize it's your last one is very difficult. The reception from the Huddersfield fans showed a lot of class and respect. It showed you that in England people really love football. I'm grateful for having had that experience in this country. In England football is special, the passion is special. I know I will not get that anywhere else in my life.'
Arsène

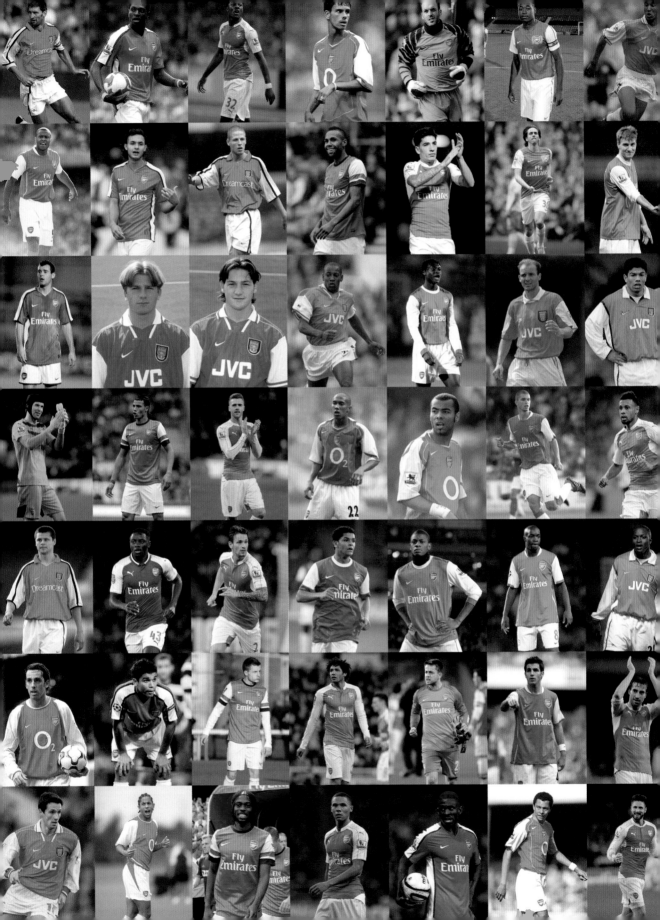

12

TWENTY-TWO YEARS

PLAYER APPEARANCES UNDER WENGER

	Player	Apps	Total	Goals
1	David Seaman	245	245	
2	Martin Keown	250+14	264	5
3	Lee Dixon	207+18	225	9
4	Tony Adams	188	188	12
5	Steve Bould	81+12	93	
6	Nigel Winterburn	155+11	166	2
7	Patrick Vieira	393+9	402	33
8	David Platt	41+27	68	8
9	Paul Merson	30	30	5
10	John Hartson	9+7	16	1
11	Ian Wright	56+3	59	33
12	Ray Parlour	270+48	318	26
13	Dennis Bergkamp	298+78	376	102
14	Steve Morrow	2+11	13	
15	Remi Garde	27+16	43	
16	John Lukic	19	19	
17	Andy Linighan	3+1	4	
18	Paul Shaw	1+7	8	2
19	Gavin McGowan	1+1	2	
20	Scott Marshall	8+5	13	
21	Stephen Hughes	35+39	74	7
22	Matthew Rose	1	1	
23	Lee Harper	1	1	
24	Ian Selley	0+1	1	
25	Nicolas Anelka	73+17	90	28
26	Gilles Grimandi	128+42	170	6
27	Emmanuel Petit	114+4	118	11
28	Marc Overmars	127+15	142	41
29	Luis Boa Morte	13+26	39	4
30	Christopher Wreh	18+28	46	5
31	Alex Manninger	63+1	64	
32	Matthew Upson	39+17	56	
33	Alberto Mendez	6+5	11	2
34	Paolo Vernazza	7+5	12	1
35	Jason Crowe	0+3	3	
36	Jehad Muntasser	0+1	1	
37	Isaiah Rankin	0+1	1	
38	Nelson Vivas	29+40	69	1
39	Freddie Ljungberg	285+43	328	72
40	David Grondin	4	4	
41	Omer Riza	0+1	1	
42	Fabian Caballero	0+3	3	
43	Michael Black	0+1	1	
44	Kaba Diawara	3+12	15	
45	Kanu	104+94	198	44
46	Silvinho	66+14	80	5
47	Oleg Luzhny	91+19	110	
48	Thierry Henry	337+40	377	228
49	Davor Suker	15+24	39	11
50	Stefan Malz	6+8	14	2
51	Tommy Black	1+1	2	
52	Rhys Weston	2+1	3	
53	Jermaine Pennant	12+14	26	3
54	Ashley Cole	218+10	228	9
55	Graham Barrett	1+2	3	
56	Brian McGovern	0+1	1	
57	Julian Gray	0+1	1	
58	Robert Pires	238+46	284	84
59	Lauren	227+14	241	9
60	Sylvain Wiltord	124+51	175	49
61	Igors Stepanovs	29+2	31	1
62	Stuart Taylor	26+4	30	
63	Moritz Volz	1+1	2	
64	Lee Canoville	0+1	1	
65	Tomas Danilevicius	0+3	3	
66	Edu	76+51	127	15
67	Sol Campbell	208+3	211	12
68	Gio van Bronckhorst	39+25	64	2
69	Francis Jeffers	13+26	39	8
70	Junichi Inamoto	2+2	4	
71	Richard Wright	22	22	
72	Stathis Tavlaridis	7+1	8	
73	John Halls	0+3	3	
74	Rohan Ricketts	0+1	1	
75	Carlin Itonga	0+1	1	
76	Juan	2	2	
77	Sebastien Svard	2+2	4	
78	Jeremie Aliadiere	19+32	51	9
79	Gilberto	213+31	244	24
80	Kolo Toure	295+31	326	14
81	Pascal Cygan	80+18	98	3
82	Ryan Garry	1+1	2	
83	Rami Shaaban	5	5	
84	David Bentley	5+4	9	1
85	Justin Hoyte	50+18	68	1
86	Jens Lehmann	199+1	200	
87	Graham Stack	5	5	
88	Gael Clichy	230+34	264	2
89	Cesc Fàbregas	266+37	303	57
90	Jerome Thomas	1+2	3	
91	Ryan Smith	2+4	6	
92	Quincy Owusu-Abeyie	8+15	23	2
93	John Spicer	0+1	1	
94	Frankie Simek	1	1	
95	Olafur-Ingi Skulason	0+1	1	
96	Michal Papadopulos	0+1	1	
97	José Antonio Reyes	89+21	110	23
98	Robin van Persie	211+67	278	132
99	Mathieu Flamini	174+72	246	13
100	Manuel Almunia	173+2	175	
101	Sebastian Larsson	7+5	12	
102	Arturo Lupoli	6+3	9	3
103	Philippe Senderos	105+12	117	4
104	Danny Karbassiyoon	1+2	3	1
105	Johan Djourou	123+21	144	1
106	Patrick Cregg	0+3	3	

No	Name	Apps	Total	Goals
107	Emmanuel Eboué	159+55	214	10
108	Alexander Hleb	109+21	130	10
109	Alex Song	179+25	204	10
110	Fabrice Muamba	2	2	
111	Anthony Stokes	0+1	1	
112	Nicklas Bendtner	83+88	171	47
113	Kerrea Gilbert	10+2	12	
114	Abou Diaby	136+44	180	19
115	Emmanuel Adebayor	114+28	142	62
116	Tomas Rosicky	158+88	246	28
117	Theo Walcott	252+145	397	108
118	William Gallas	142	142	17
119	Julio Baptista	17+18	35	10
120	Matthew Connolly	1+1	2	
121	Denilson	120+33	153	10
122	Armand Traore	28+4	32	
123	Mark Randall	4+9	13	
124	Mart Poom	1+1	2	
125	Bacary Sagna	272+12	284	5
126	Eduardo	41+26	67	20
127	Lassana Diarra	8+5	13	
128	Lukasz Fabianski	75+3	78	
129	Fran Merida	7+9	16	2
130	Kieran Gibbs	183+47	230	6
131	Henri Lansbury	1+7	8	1
132	Nacer Barazite	0+3	3	
133	Aaron Ramsey	237+92	329	58
134	Samir Nasri	110+15	125	27
135	Carlos Vela	19+43	62	11
136	Jack Wilshere	150+47	197	14
137	Gavin Hoyte	4	4	
138	Francis Coquelin	115+45	160	0
139	Jay Simpson	1+2	3	2
140	Mikael Silvestre	37+6	43	3
141	Amaury Bischoff	0+4	4	
142	Rui Fonte	0+1	1	
143	Paul Rodgers	1	1	
144	Andrey Arshavin	97+47	144	31
145	Vito Mannone	22+1	23	
146	Thomas Vermaelen	136+14	150	15
147	Wojciech Szczesny	181	181	
148	Sanchez Watt	1+2	3	1
149	Gilles Sunu	1+1	2	
150	Craig Eastmond	7+3	10	
151	Kyle Bartley	1	1	
152	Thomas Cruise	1	1	
153	Jay Emmanuel-Thomas	1+4	5	
154	Marouane Chamakh	36+31	67	14
155	Laurent Koscielny	318+6	324	24
156	Sebastien Squillaci	35+4	39	2
157	Ignasi Miquel	9+5	14	1
158	Conor Henderson	1	1	
159	Gervinho	44+19	63	11
160	Emmanuel Frimpong	10+6	16	
161	Carl Jenkinson	48+14	62	1
162	Alex Oxlade-Chamberlain	115+83	198	20
163	Per Mertesacker	215+6	221	10
164	Mikel Arteta	131+19	150	16
165	Yossi Benayoun	15+10	25	6
166	Andre Santos	21+12	33	3
167	Ju Young Park	4+3	7	1
168	Ryo Miyaichi	2+5	7	
169	Oguzhan Ozyakup	0+2	2	
170	Chuks Aneke	0+1	1	
171	Nico Yennaris	2+2	4	
172	Daniel Boateng	0+1	1	
173	Santi Cazorla	166+14	180	29
174	Lukas Podolski	55+27	82	31
175	Olivier Giroud	169+84	253	105
176	Martin Angha	1+1	2	
177	Emiliano Martinez	12+1	13	
178	Serge Gnabry	9+9	18	1
179	Thomas Eisfeld	1+1	2	1
180	Jernade Meade	1+1	2	
181	Nacho Monreal	187+25	212	9
182	Yaya Sanogo	9+11	20	1
183	Mesut Ozil	187+9	196	37
184	Chuba Akpom	1+11	12	
185	Isaac Hayden	2	2	
186	Kristoffer Olsson	0+1	1	
187	Hector Bellerin	150+12	162	7
188	Gedion Zelalem	0+4	4	
189	Kim Kallstrom	1+3	4	
190	Mathieu Debuchy	29+1	30	2
191	Calum Chambers	57+26	83	3
192	Alexis Sanchez	153+13	166	80
193	Joel Campbell	23+17	40	4
194	Danny Welbeck	70+42	111	27
195	David Ospina	67+3	70	
196	Ainsley Maitland-Niles	24+14	38	
197	Stefan O'Connor	0+1	1	
198	Gabriel	53+11	64	1
199	Petr Cech	117	117	
200	Alex Iwobi	71+27	98	9
201	Glen Kamara	1	1	
202	Ismael Bennacer	0+1	1	
203	Krystian Bielik	0+2	2	
204	Jeff Reine-Adelaide	5+3	8	
205	Mohamed Elneny	52+20	72	2
206	Rob Holding	39+5	44	1
207	Granit Xhaka	85+9	94	7
208	Shkodran Mustafi	73+2	75	5
209	Lucas Perez	9+12	21	7
210	Chris Willock	0+2	2	0
211	Alexandre Lacazette	33+6	39	17
212	Sead Kolasinac	28+8	36	5
213	Reiss Nelson	8+8	16	
214	Josh Dasilva	0+3	3	
215	Joe Willock	6+5	11	
216	Marcus McGuane	0+2	2	0
217	Eddie Nketiah	0+10	10	2
218	Ben Sheaf	0+2	2	
219	Matt Macey	2	2	
220	Henrikh Mkhitaryan	14+3	17	3
221	Pierre-Emerick Aubameyang	13+1	14	10
222	Dinos Mavropanos	3	3	

ARSÈNE WENGER

Born

Strasbourg, 22 October 1949

Playing career

1969-1973	Mutzig
1973-1975	Mulhouse
1975-1978	ASPV Strasbourg
1978-1981	RC Strasbourg

Management career

1984-1987	Nancy-Lorraine
1987-1994	AS Monaco
1995-1996	Nagoya Grampus Eight
1996-2018	Arsenal

Playing Honours

RC Strasbourg Ligue 1 1979

Managerial Honours

Monaco	Ligue 1 1988
	Coupe de France 1991
Grampus Eight	Emperor's Cup 1995
Arsenal	Premier League 1998, 2002, 2004
	FA Cup 1998, 2002, 2003, 2005, 2014, 2015, 2017

❛The top picture was taken on the first day I was introduced at Highbury. The picture below was taken almost 20 years later. I noticed the seats at the Emirates felt bigger than those at Highbury. The club has grown a lot in that time. I have lived and breathed football all these years and it's a passion – I can't imagine doing anything else.❜
Arsène

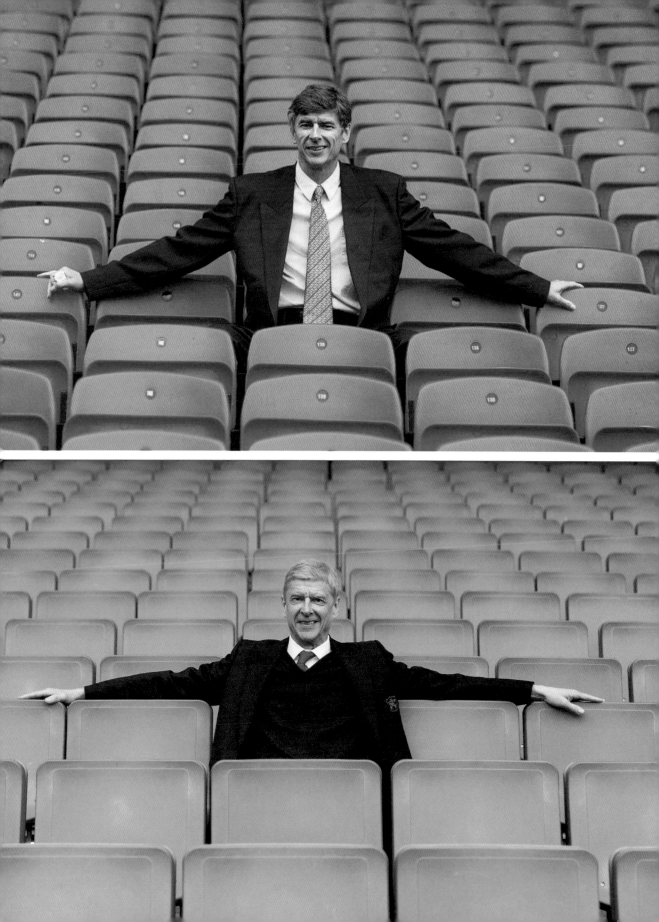

PHOTO ACKNOWLEDGEMENTS

The Arsenal Foundation uses the power of football and the Arsenal name to inspire and support young people in north London and across the globe. Just knowing Arsenal cares can be a huge source of motivation for young people facing difficulties in their lives. Locally and internationally, the club and The Arsenal Foundation support a wide range of community and charitable projects. Help ranges from refurbishing football pitches on estates and schools around Emirates Stadium to building pitches in camps for internally displaced people in Iraq to give boys and girls fleeing war a safe place to play and the chance to be children again. From bringing together survivors of torture for football coaching and language lessons to supporting global emergency appeals, The Arsenal Foundation believes in giving young people the right support to thrive.

To find out more visit **www.arsenal.com/thearsenalfoundation**